THE ART OF
DECEPTION

ILLUSIONS TO CHALLENGE THE EYE AND THE MIND

BRAD HONEYCUTT

FOREWORD BY JOHN LANGDON
EPILOGUE BY SCOTT KIM

imagine!
Publishing

DEDICATION

For Jennifer

An Imagine Book
Published by Charlesbridge
85 Main Street
Watertown, MA 02472
(617) 926-0329
www.charlesbridge.com

Library of Congress Control Number: 2014931352
ISBN 13: 978-1-62354-037-1
Printed in China. Manufactured in April, 2014.

(hc) 10 9 8 7 6 5 4 3 2 1

Designed by Melissa Gerber

For information about custom editions, special sales, premium and corporate purchases, please contact Charlesbridge
Publishing at specialsales@charlesbridge.com.

CONTENTS

FOREWORD

It should come as no surprise that the topic of optical illusions is a rather elusive one. We experience optical illusions all the time, and our eyes deceive us. Distant scenes appear flat, in that we may perceive everything beyond a certain distance to be in (or out) of focus. Things that are far away appear to be smaller than they really are. When we see with only one eye, depth perception is lost. "Realistic" photographs are two-dimensional representations of things that we know to be three-dimensional. Fish, flies, and fowl see differently than we do. Whose "reality" is right? All of them? None of them? Are they all optical illusions? Do the eyes "see" or does the brain? Obviously, both are required, but images are created in the brain with data received through the eyes. Artists creating intentionally deceptive illusions have many of these "tools" at their disposal.

All two-dimensional images—photographs, paintings, maps, diagrams, and alphabets—are created by a person whose vision is different from everyone else's, because the artist's brain is different from everyone else's. That vision may be an ocular, intellectual, or spiritual approach that, perhaps unconsciously, guides her or his way of relating to the world. Art depends on, and is evidence that, each individual sees things differently. In fact, the whole point of creating art is to share one's different ways of seeing or understanding.

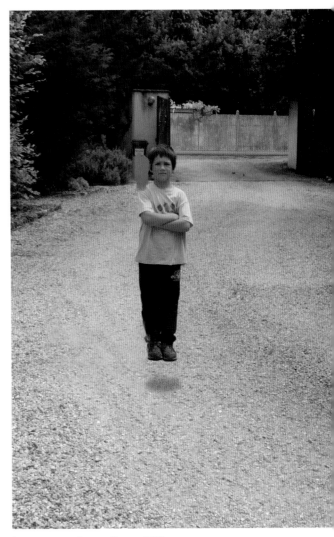

LEVITATION BY DANIEL PICON, 2011

Of course, a great deal of the visible world is commonly agreed upon, and we call that common vision reality, so when an artist sets out to purposely, and purposefully, create a deceptive illusion, it must be presented in the context of that shared understanding of our surroundings. That shared reality may occupy almost the entire image, with just a little detail that can undo our assumptions. Daniel Picon's *Levitation* is an excellent example.

Or perhaps, when little or none of the visual information before us seems "normal," the context must be provided by the viewer's life experience. Joe Burull's *Leaf* presents a completely straightforward photograph of a familiar object, and yet we see it instantly as something else that is even more familiar. Hermann Paulsen's, Andreas Aronsson's, and Oscar Reutersvärd's "constructed" diagrams show us flat polygons that remind us so much of cubes and other solids that we have to look again to remind ourselves that that arrangement of shapes is only possible in a two-dimensional reality.

As a rule, optical illusions feature, and depend on, ambiguity. Ambiguity is a tantalizing situation in which more than one interpretation is valid. Rob Gonsalves' paintings are great examples of the importance of ambiguity.

LEAF BY JOE BURULL, 2002

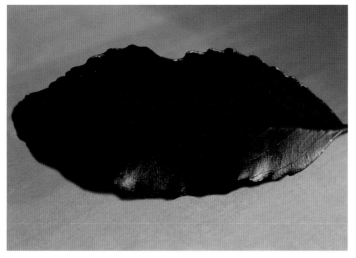

IMPOSSIBLE WINDOW BY OSCAR REUTERSVÄRD

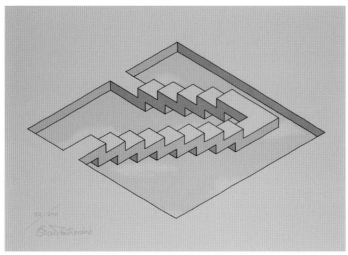

His subjects blend seamlessly from one credible interpretation to another. The phrase "repetition with variation" describes ambiguity well, but is a fundamental cornerstone of all artistic expression. Many artists have painted the same subject, each providing his or her unique treatment—each works from a different physical, intellectual, or philosophic vantage point—and in the case of Jane Perkins' *Girl with a Pearl Earring*, simply by using an unexpected medium. Such familiar images can provide a new and "re-newed" enjoyment when re-imagined by a more recent artist. This is true of the many confounding illusions inspired by the work of M.C. Escher that can be found in this book.

Repetition is required as a way to provide a context, a familiar setting within which the viewer may feel comfortable enough to continue the experience. If familiarity is all the work provides, though, it's boring. The experience will not last very long. Variation is required to provide interest, entertainment, or enlightenment, but completely unfamiliar images will often

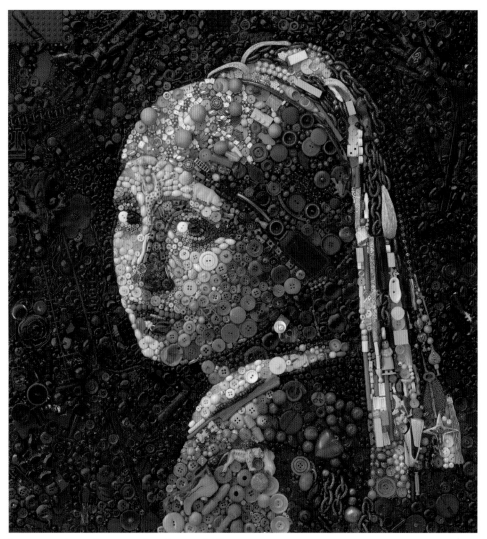

GIRL WITH A PEARL EARRING BY JANE PERKINS, 2011

turn the viewer away, as much as abstract art did in the early twentieth century. Abstract art had to win its own familiarity. The deceptive images in this volume provide both repetition *and* variation, each in its own carefully balanced way.

Repetition with variation is the *sine qua non* of the art of illusion. It would be a gross disservice to refer to the work in this book as "trickery," but as with magic acts, practical jokes, and surprise parties, the viewer must be provided with a familiar, but deceitful reality as the set-up for the surprise. A successful ambigram, for example,

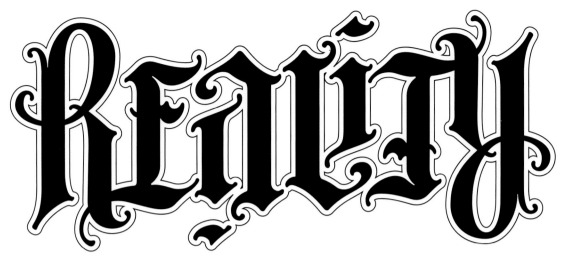

must be a recognizable (if highly stylized) presentation of a familiar word, and yet each letter is an individual optical illusion. While appearing to be a familiar letter, it also performs the role of another letter, concealed until the design is viewed from a second point of view.

Philosophically speaking, there are important life lessons in these works: life is a series of familiar experiences, punctuated by variations from our quotidian existence. Some of them are anticipated. Others take us by surprise. The works of art in this volume teach us to expect the unexpected. We learn about reality through images that portray something else.

—John Langdon
Artist, Author, and Professor of Typography

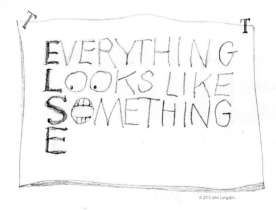

INTRODUCTION

"Art is a deception that creates real emotions—a lie that creates a truth. And when you give yourself over to that deception, it becomes magic."

— Marco Tempest, Cyber Illusionist

My first book, *The Art of the Illusion* (coauthored with Terry Stickels), showcased amazing illusion art created by a diverse mix of talented artists. If you are familiar with this book, or if you are a long-time fan of optical illusions and deceptive art, you will certainly recognize a number of artists appearing within these pages. You will find magical paintings from Rob Gonsalves, brilliant ambigrams from John Langdon and Scott Kim, metamorphic portraits from Octavio Ocampo, impossible and ambiguous designs from Gianni A. Sarcone and István Orosz, clever illustrations from Chow Hon Lam and Dick Termes, and many more. In a unique approach, this book uses insightful interviews and discussion to reveal the magic and the science that makes optical illusions so intriguing and eye opening. These remarkable artists talk about their technique, vision, and their ability to fool the eye and the mind.

The majority of this book, however, is devoted to deceptive art from artists who did not appear in *The Art of the Illusion*. You will find the camouflaged artwork of Bev Doolittle and Liu Bolin, "two-in-one" paintings from Oleg Shupliak, masterful photo manipulations from Erik Johansson and Thomas Barbèy, three-dimensional anamorphic art painted onto pavement from Kurt Wenner, Tracy Lee Stum, and Leon Keer, landscapes created entirely using food from Carl Warner, and more. These painters, illustrators, sculptors, photographers, and researchers come from diverse backgrounds from all over the world. Some are well known, while others will likely be unfamiliar to most. Despite their divergent backgrounds, all of these artists share a common trait. They each possess the ability to capture magical and deceptive ideas, and present them to the world.

One of the most intriguing elements of illusion art is that it need not be complicated to make a powerful statement. Take *Turning the Tables* from Roger Shepard at right and on page 106, for example. This simple black and white drawing goes against everything that our eyes and brains tell us about the world around us. In this illustration, two tables are presented side-by-side. The table on the left is oriented vertically and the one on the right is more horizontal. The tabletop on the left appears to be a completely different size than the one on the right. It would be difficult for someone to say that the tabletops look identical to each other, but that is exactly the case. Don't believe it? Make a copy of this page and cut out one of the tabletops, or carefully trace one of them onto a sheet of paper. You will end up with a parallelogram that is the exact same size as the other. Even after you confirm that the two tabletops are identical, the next time you see this illusion, the tabletops will look completely different again.

The illusion still works (albeit not quite as strongly) even if the edges and legs of the tables are removed so that only two parallelograms remain. Even in the absence of other cues, we tend to see these flat shapes as if they were in perspective.

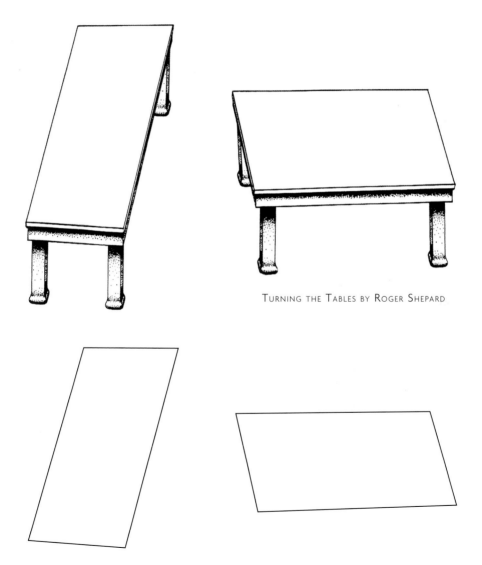

TURNING THE TABLES BY ROGER SHEPARD

Of course, many examples of illusion art are extremely complex and take considerable time, effort, and specialized skill to create. In *Go Your Own Road* from Erik Johansson below and on page 27, for example, we are presented with a photograph that can probably best be described as confusing. A road winds through the quiet countryside, but an unexpected twist lies at the end of this road. The entire scene looks like it could have been captured with a camera, even though our brain tells us that it would certainly not be possible to do so. The photograph is only possible when

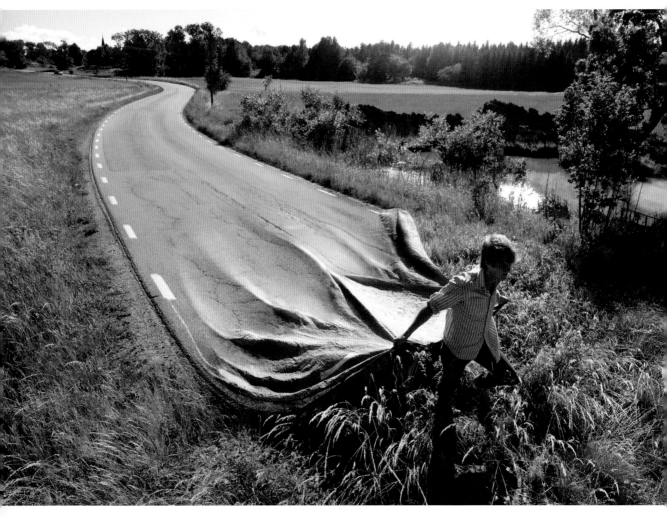

GO YOUR OWN ROAD BY ERIK JOHANSSON, 2008

multiple photographs with the same perspective and lighting are combined with the help of computer software such as Adobe Photoshop. After many hours of work and hundreds of layers of detail, a photograph of an idea, rather than a moment in time, is born. The complexity, of course, lies in the combination of the different component photographs. In order to sell the viewer that it could be a single image, the transition must be seamless such that it is impossible to tell where one photograph ends and another begins. The end result is magic.

Through both intentional and accidental deception, the artists appearing throughout this book can make us see things that do not really exist, defy our expectations, hide alternative meanings in plain sight, and make two-dimensional objects appear to jump off the page. My hope is that through the examination of the talents and imaginations of these artists, we will be able to recognize that the way we see the world with our own eyes cannot always be fully trusted. If in the process we find ourselves entertained, then I would say that can only be a good thing.

—**Brad Honeycutt**

GALLERY

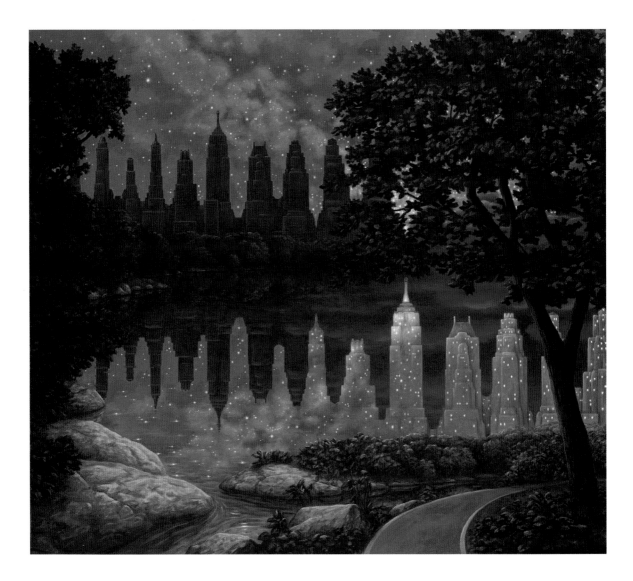

ROB GONSALVES

When the Lights Were Out, 2013

Canadian artist Rob Gonsalves paints surreal scenes that inject a sense of magic into realistic settings. As such, he describes the
style of his own work as "Magic Realism." In this example, Gonsalves portrays a magical scene during what might be a power
outage in a big city. When the dark row of skyscrapers reflects on the surface of the lake, the city suddenly comes alive.

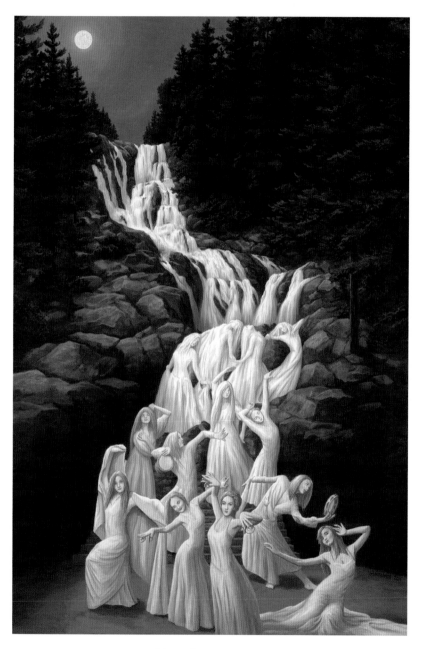

ROB GONSALVES

Water Dancers, 2011

Female dancers in white gowns appear to seamlessly emerge from the crashing water of a moonlit waterfall. Instead of a pool of water at the base of the falls, we are presented with graceful dancers performing under the night sky. Like most works from the imagination of Gonsalves, the magical transformation present in this painting has a dream-like feeling to it.

ROB GONSALVES

As Above and So Below, 2011
Gonsalves cites perspective illusionist M.C. Escher and surrealist painters Salvador Dalí, Yves Tanguy, and René Magritte as early influences. Today, Gonsalves is recognized as one of the most famous living surrealist painters in North America.

Rob Gonsalves

The Space Between Words, 2013

In addition to his limited edition prints, Gonsalves's paintings have appeared in a series of books titled *Imagine a Night*, *Imagine a Day*, and *Imagine a Place*. All three books can be enjoyed by readers of all ages, and feature text by Sarah L. Thomson. In this painting, it seems that the readers are literally stepping into the books that they are reading. In doing so, a window opens into a new world created by the words the author has written on paper.

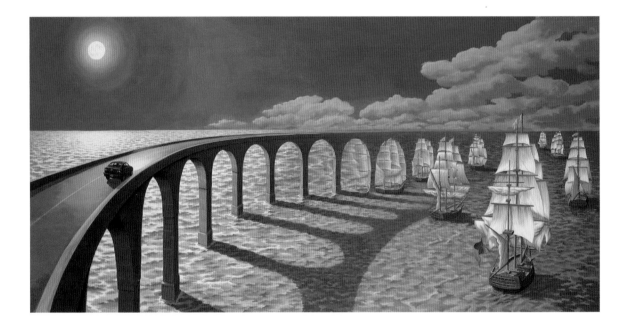

ROB GONSALVES

Toward the Horizon, 2012

This painting is a new take on a previous masterpiece created by Gonsalves that has been sold out for quite some time. The original, titled *The Sun Sets Sail*, presents an arched bridge in the distance that transforms into magnificent tall sailing ships as it approaches the viewer. This painting is presented from the opposite perspective, as the ships in the distance line up to form the arches on the bridge the car is travelling on.

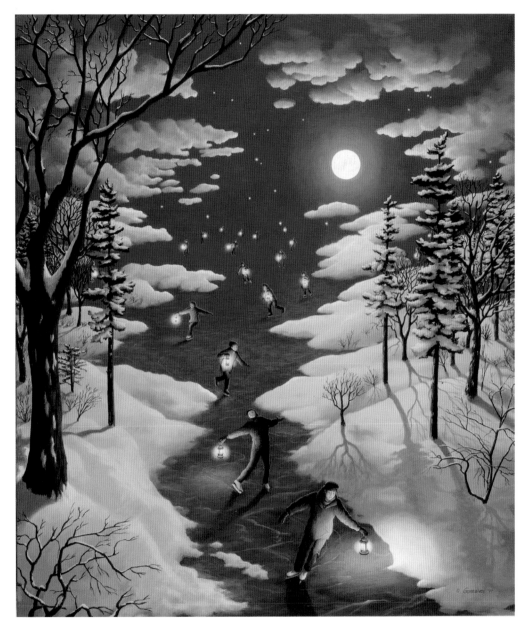

Rob Gonsalves

Nocturnal Skating, 1997

White clouds become snow-covered ground, the cold night sky becomes ice covering a creek, and stars become lantern-carrying ice skaters as this painting is viewed from the top to the bottom. Gonsalves spends a considerable amount of time on each of his paintings to ensure that such transitions are absolutely perfect. He became a full-time artist after receiving positive responses to his artwork in 1990 at the Toronto Outdoor Art Exhibition.

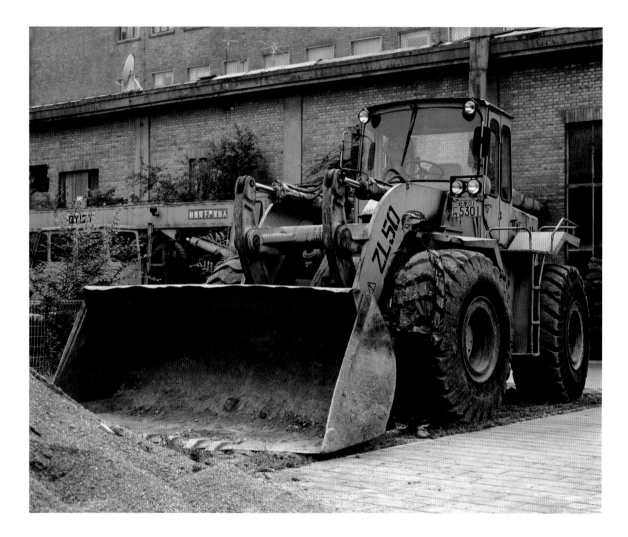

Liu Bolin

Hiding in the City No. 71 – Bulldozer, 2008

In his work, Liu Bolin generally explores the theme of the rapid industrial growth in China and its effects on mankind and nature. He consistently questions whether the changes we make to advance technologically will one day bring us to ruin. He worries that for the sake of progress, humans disregard the well-being of our world and our bodies. By disappearing into specific scenes, Liu Bolin wants to draw the attention away from himself, directing it instead at a background chosen to convey a particular message of the dangers we create for ourselves.

LIU BOLIN

Hiding in the City – Mobile Phone, 2012

In this work, Bolin hides himself in a vast amount of mobile phones. In an artist statement about this photograph, Bolin notes, "My intention with this photograph lies in questioning the contradictory relationship between man-made civilization and human nature. In the future, we will pay for our continued ignorance."

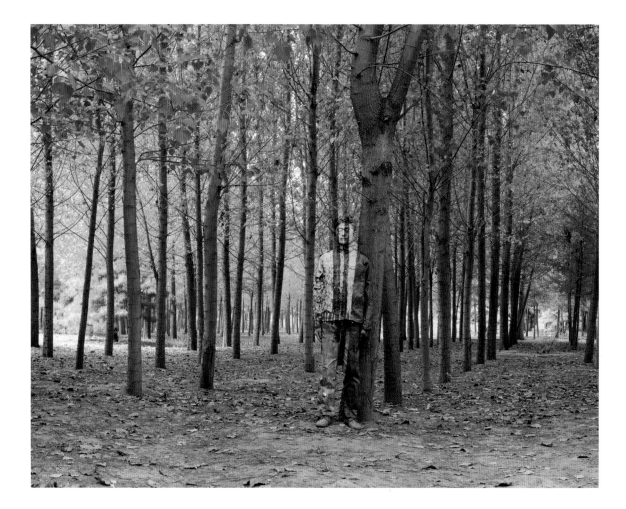

LIU BOLIN

Hiding in the City No. 94 – In The Woods, 2010

Regarding this photograph, Bolin notes, "This image was taken near the airport in Beijing. In the past decade, Beijing has undergone tremendous changes. Many of the old streets have changed, and there has been much demolition and re-planning of buildings. One day, I passed a demolition site in the Chaoyang district and noticed that all of the trees had been cut down. I had this feeling that all of Beijing's trees will eventually be moved to the outskirts. In this work, I am expressing my concerns for the future industrialization of Beijing."

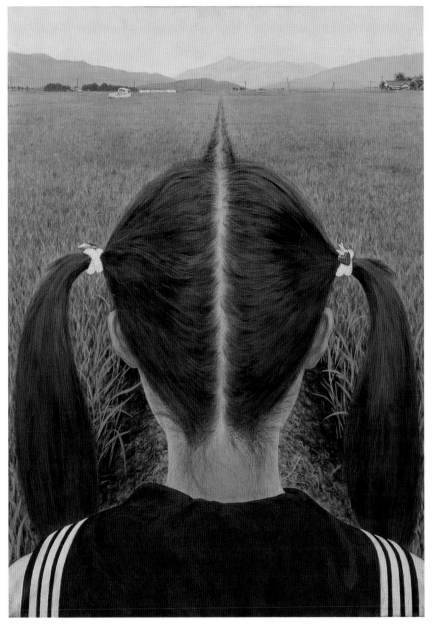

AIDA MAKOTO

AZEMICHI (a path between rice fields), 1991
In the catalog *Monument for Nothing* published by Graphic-Sha Publishing Co., Ltd., Aida Makoto writes, "The idea for this piece came to me when I was watching with sleepy eyes the back of my girlfriend preparing herself in the morning and separating her hair in the middle. While painting this image, I was thinking a bit about "Road" by Kaii Higashiyama (a 20th-century Japanese master landscape painter) and the paintings of René Magritte."

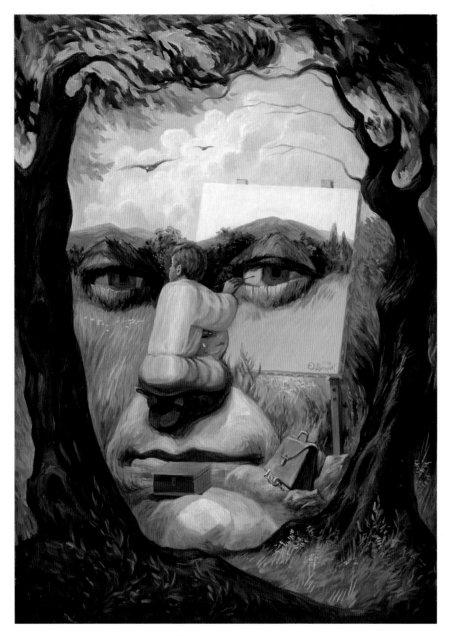

OLEG SHUPLIAK

Self Portrait, 2011

Ukrainian artist Oleg Shupliak creates uniquely deceptive paintings that he refers to as "two-in-one" paintings. His works feature portraits of people (often well-known) merging into the landscapes around them. He first began painting these works in 1991, and his collection now numbers nearly one hundred. In this illusion, a man paints a scene of a cozy cottage on a canvas as he kneels between two trees. The entire scene also happens to make up a larger self-portrait.

OLEG SHUPLIAK

Spirit of Freedom, 2012

Shupliak created the first version of this painting in 1991, when Ukraine became independent following the break-up of the Soviet Union. It features a portrait of Ukrainian poet and artist Taras Shevchenko that might require a double take to see clearly. In the scene, a man with an instrument becomes the nose and mouth of Shevchenko, and two passing sailboats transform into his eyes. Several trees and a soaring bird combine to further form the outline of his head and face.

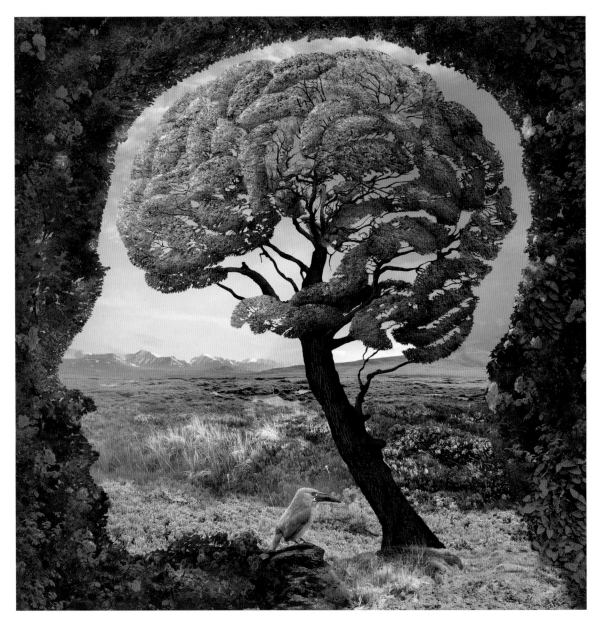

Igor Morski

Nature, 2012

Created as part of a series for a magazine celebrating the four seasons of nature, this digital illustration has a double meaning. Upon first glance, a solemn tree sits alone with a colorful bird in the foreground. Snow-capped mountains and a river can be seen in the distance. The shape of the purple foliage on the tree, however, carries a strong resemblance to a human brain, while the trunk of the tree doubles as a brain stem. The net effect is a scene that speaks volumes to the inter-connectedness of humans and their natural surroundings.

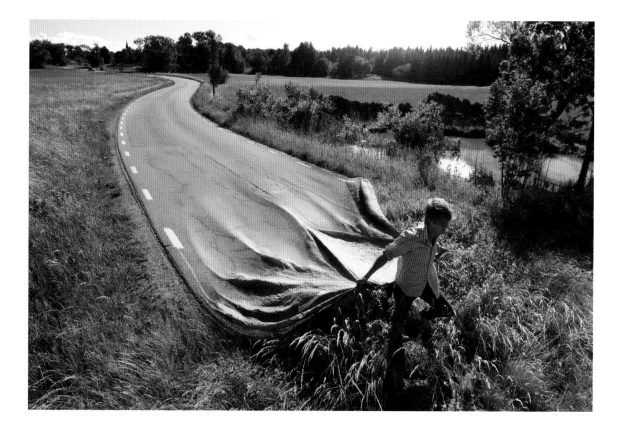

ERIK JOHANSSON

Go Your Own Road, 2008

Erik Johansson is a photographer and retouch artist from Sweden who uses photography as a way of collecting material to realize the ideas that are in his mind. He creates photo-manipulations by taking multiple photographs and crafting them into creative and impossible scenes using Photoshop. "It is about capturing the imaginable and realizing the impossible," Johansson noted in a lecture on his creative process. "I think that what you can imagine is what you can create."

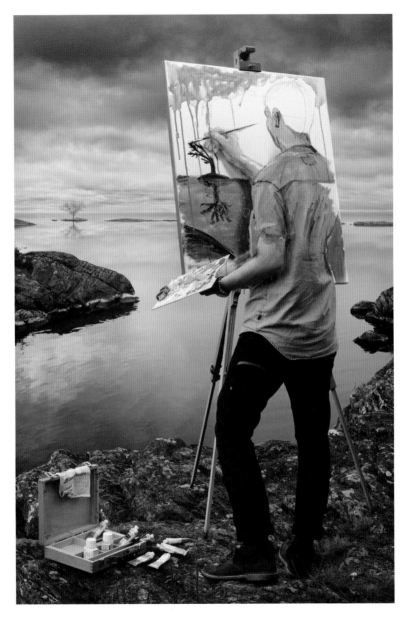

ERIK JOHANSSON

Self-Actualization, 2011

To create this manipulated scene, Johansson first took a photograph of the painter standing in front of a blank white canvas with Värnen, Sweden, as the background. While the painting on the canvas could have easily been done later using Photoshop, Johansson instead decided to paint it by hand, re-photograph it, and then edit the original image to swap the blank canvas for the freshly painted one. In doing so, Johansson felt he would be able to keep the final image as realistic as possible.

ERIK JOHANSSON

Work At Sea, 2007

Johansson believes that when you take a photograph with a camera, the process ends when you press the trigger. In that respect, it is about being in the right place at the right time. His aim is to create something different, where the process begins once the trigger is pressed. In each of his works, he tries to capture an idea, rather than a moment while maintaining a sense of realism. Even though his photographs depict impossible scenes, they look as if they could have been captured as a single photograph.

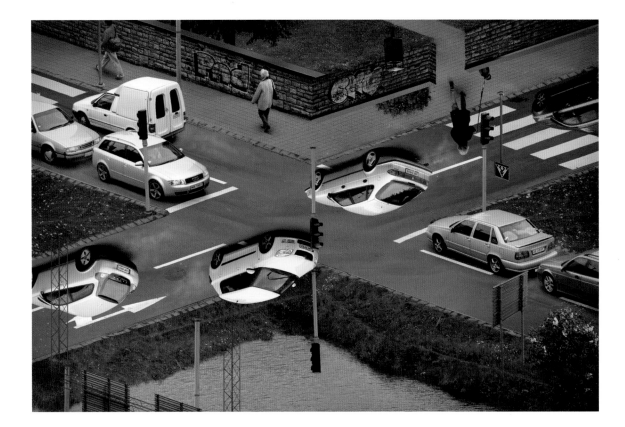

ERIK JOHANSSON

Common Sense Crossing, 2010

Looking at this very strange intersection for extended periods of time can lead to a somewhat uneasy feeling. It is hard to tell if you are looking up or down at the cars on the street. On one street, the cars, pedestrians, and street signs appear to be right side up, but on the intersecting street, everything seems to be upside down.

ERIK JOHANSSON

Downside of the Upside, 2009

Johansson enjoys illusions as they take something and make it look like something else. He particularly
likes the perspective illusions of M.C. Escher and the surrealistic paintings of Salvador Dalí. When creating
one of his own works, he tries to incorporate similar techniques using photography. Here, he has mixed
two photographs with completely different perspectives and merged them into a single scene.

Cesar Del Valle

Portraits II 7, 2007

Colombian artist Cesar Del Valle's drawings could easily be mistaken for photographs. His realistic characters drawn with pencil on paper appear to interact with their environment. In this example, a woman uses a string to pull down the corner of the same sheet of paper that she is drawn on.

Cesar Del Valle

Portraits III 7, 2008

In this drawing, a man fights for his own survival as the paper above him begins to crumple. The "crumpled" portion is entirely hand drawn with pencil, even though it looks like an actual sheet of paper was used to create the illusion. Del Valle, who studied at the University of Antioquia in Medellin, Colombia, states, "My artwork is based on drawing and its common elements, driving attention toward its forms: dot, line and plane; and toward its materials: in this case, graphite and paper."

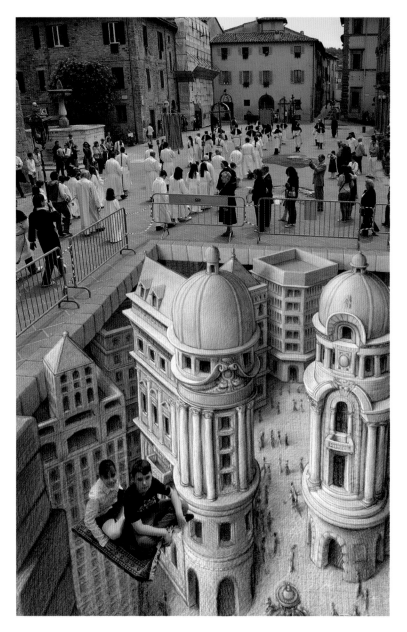

KURT WENNER

Magic Carpet, 2005

In the 1980s, Kurt Wenner began to incorporate elements of anamorphic perspective into his street paintings. When viewed from a specific vantage point, these paintings rendered on a flat surface had the appearance of being three-dimensional. From all other angles, the paintings appear to have a distorted perspective. In doing so, Wenner created a modern revolution in this art form that has come to be known as 3D pavement art. This particular anamorphic street painting was created in Bettona, Italy, during the festival of Corpus Christi. It features Wenner's son and a friend on a carpet, flying high above a magical city.

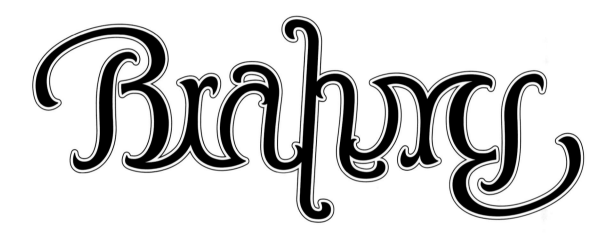

SCOTT KIM

Brahms, 2006

Being a classical pianist himself, Scott Kim cites Johannes Brahms as one of his heroes. This design, which reads exactly the same upside down, was created as part of a series of ambigrams based on the names of famous classical composers for his 2008 Mind Benders and Brainteasers page-a-day puzzle calendar published by Workman Publishing. He notes, "I am especially fond of his rich sonorous chord voicing, so I developed a lettering style that has a rich, somewhat ornate texture."

0 ZERO 5 FIVE
1 ONE 6 SIX
2 TWO 7 SEVEN
3 THREE 8 EIGHT
4 FOUR 9 NINE

SCOTT KIM

Numbers, 1982

Kim created this design to be used as the opening illustration for a chapter about number paradoxes in Martin Gardner's book *Aha! Gotcha*. His challenge was to make sure that he included all ten digits in the letter shape: no more, no less. Of all of numbers, eight and nine proved to be the most challenging to turn into letters.

SCOTT KIM

Korea/America, 2007

This ambigram was created to accompany an article about Kim published in *KoreAm Journal*, a monthly magazine that analyzes news, culture, entertainment, sports, politics, and people of Korean America. "My connection to Korea is a bit distant," Kim says. "My grandfather came to America in the first wave of immigration in 1903, so it was great to be recognized as a Korean American. To turn a five-letter name into a seven-letter name, I bookended the design with curved strokes that form the As of AMERICA, but ignored them in KOREA. The red, white, and blue coloring reflects both the American flag and the Korean flag."

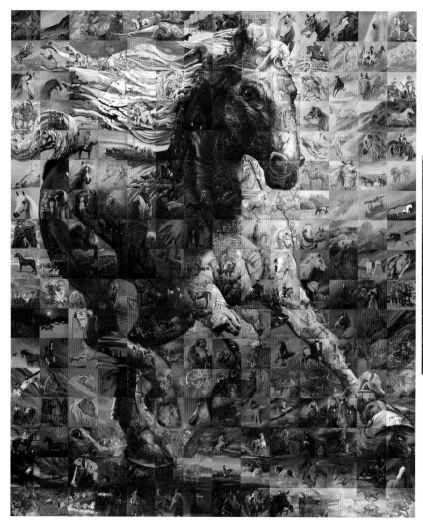

LEWIS LAVOIE

The Horse Gift, 2008

This collaborative mural celebrates horses by assembling 238 equine-themed paintings from 174 different artists in a way that presents a larger picture. The mural itself stands 23 feet high by 19 feet wide, and was created entirely by hand. None of the artists involved were told exactly what the final image would be. They were told to work in certain shapes, colors, and tones, and to create a painting with a horse theme. The smaller, detailed image of the horse's eye to the right shows several of the individual paintings in greater detail. This mural has been touring North America in various exhibits since 2008.

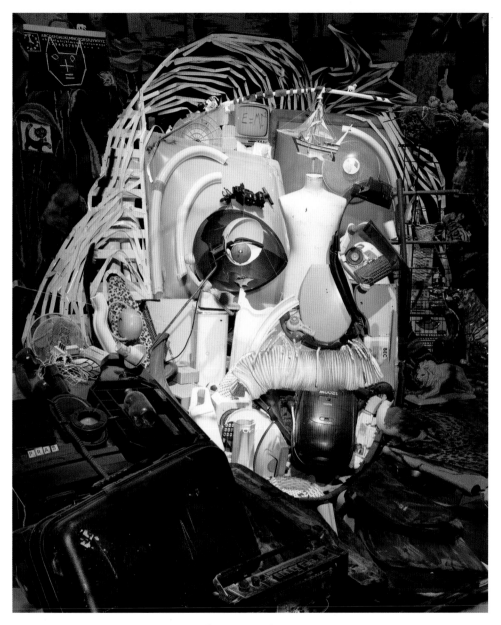

Bernard Pras

Einstein, 2000

Bernard Pras creates works of art by arranging miscellaneous objects into recognizable images. Shown here, a collection of junk has been assembled to recreate a famous photograph of physicist Albert Einstein. Suitcases, a sailboat, a mannequin, a telephone, a lion statue, and other discarded items have been strategically placed to create this remarkable illusion. Each time Pras begins a new art installation, he gets the feeling that he will not be able to make it work exactly as planned. He notes, "If I were sure I'd reach my goal every time, I'd do something else."

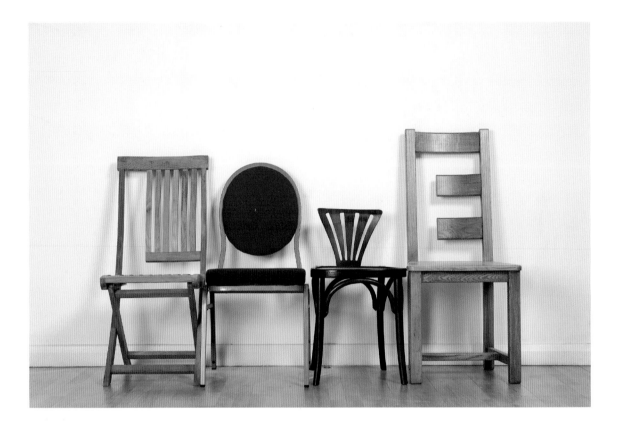

JAMES HOPKINS

Love Seat, 2007

British artist James Hopkins transforms everyday items into sophisticated illusions. "'I noticed the shape of some chairs was similar to the letters of the alphabet," says Hopkins. "By removing certain sections from the chairs, I could reveal a message that commented on the possibilities of the chair's function. Love is the hidden meaning but we don't see that initially because we choose to see what is first presented to the mind, in this case the chairs."

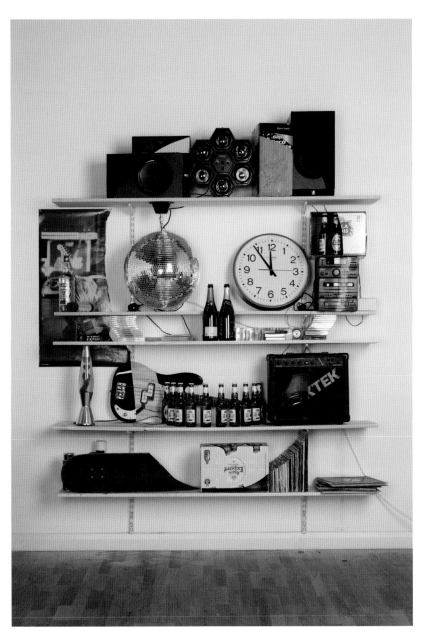

JAMES HOPKINS

Wasted Youth, 2006

Hopkins holds Fine Art degrees from both University of Brighton and Goldsmiths College, University of London. His mixed media work shown here measures 75 by 62 by 12 inches, and consists of a series of shelves that might fit well in a college student's apartment. The lights, speakers, bottles, disco ball, clock, stereo, guitar, lava lamp, skateboard deck, compact discs, vinyl records, and other objects resting on the shelves resemble something sinister.

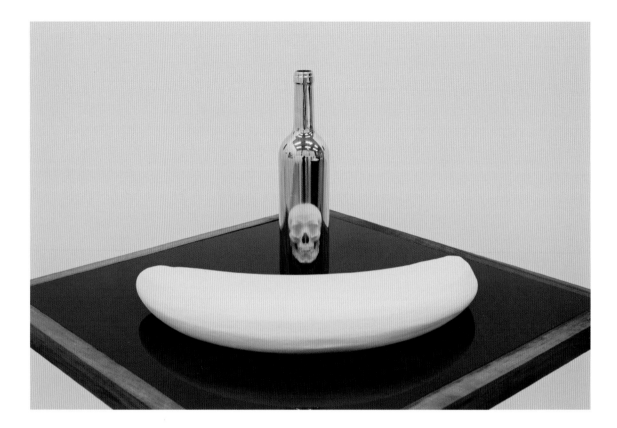

JAMES HOPKINS

Ghost, 2011

A white mass rests in front of wine bottle. Upon closer examination, the reflection of the white mass forms the shape of a human skull in the bottle's mirrored finish. By examining this work from the opposite angle (see facing page), the trick behind the illusion is revealed. The backside of the white mass is an anamorphic sculpture designed to form a recognizable image of a skull when reflected in the curved mirrored surface of the bottle.

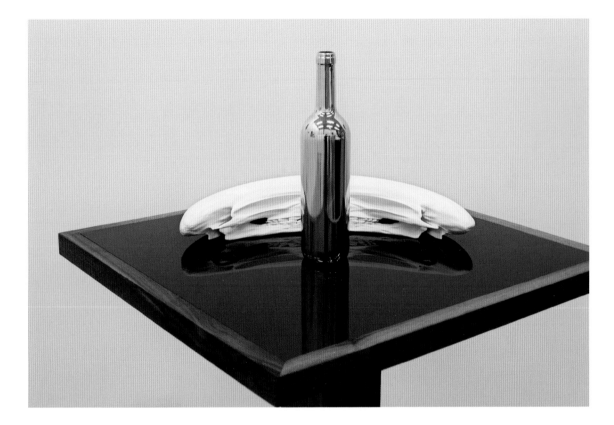

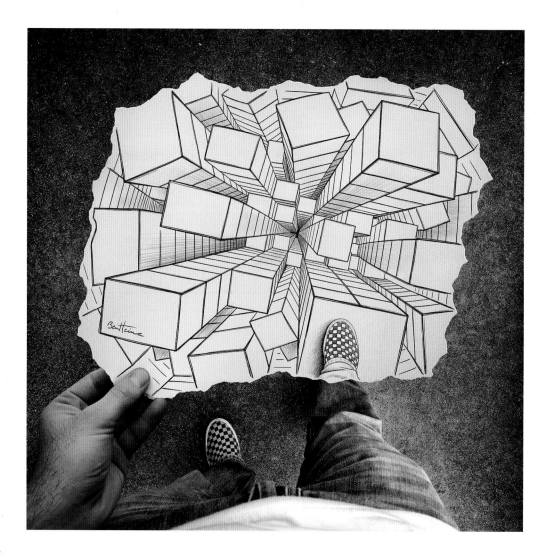

Ben Heine

Pencil Vs Camera – 32, 2010

Visual artist Ben Heine's Pencil Vs Camera series mixes drawing and photography, imagination and reality. In this photograph taken in Cologne, Germany, Heine is holding a three-dimensional sketch that allows the viewer to step into a new dimension. "I just make art for people," says Heine. "I want them to dream and forget their daily troubles."

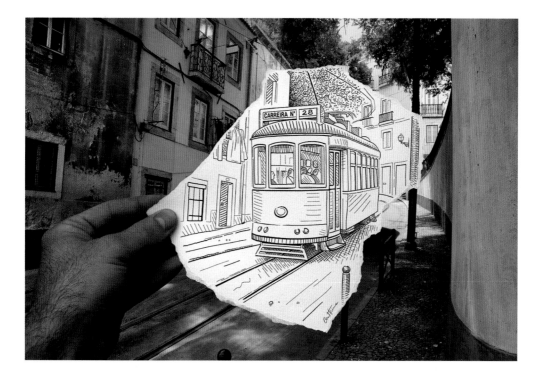

BEN HEINE

Pencil Vs Camera – 4, 2010

Tram 28 in Lisbon, Portugal runs through the narrow and steep streets of the Alfama district. Here,
a likeness of the tram sketched on a sheet of paper is held in front of the camera and a photograph
is taken. As with all of the works in this series, Heine's hand is clearly visible in the photograph.
Heine says the hand represents the connection between the artist, the artwork, and the viewer.

49/125

ConReutersvard

OSCAR REUTERSVÄRD

Impossible Figure

Oscar Reutersvärd, born in 1915 in Stockholm, Sweden, is known as "the father of the impossible figure."
He earned this title by being the first artist to explore impossible figures as a legitimate art form. In 1934,
he created the first impossible triangle from a series of cubes. Mathematician Roger Penrose would later
describe Reutersvärd's work as "impossibility in its purest form." This variation of the original impossible
triangle features an additional cube floating on each of the figure's three sides.

Oscar Reutersvärd

Impossible Figure

Over his lifetime, Reutersvärd created thousands of impossible figures. Today, artists are still learning from his works, creating derivatives of his impossible geometric creations and paying homage to him in a variety of ways. Mathematicians, psychologists, and researchers continue to study his work in the area of visual perception. The V-shaped portion of this figure intersects the center vertical post at two points in a manner that is not possible.

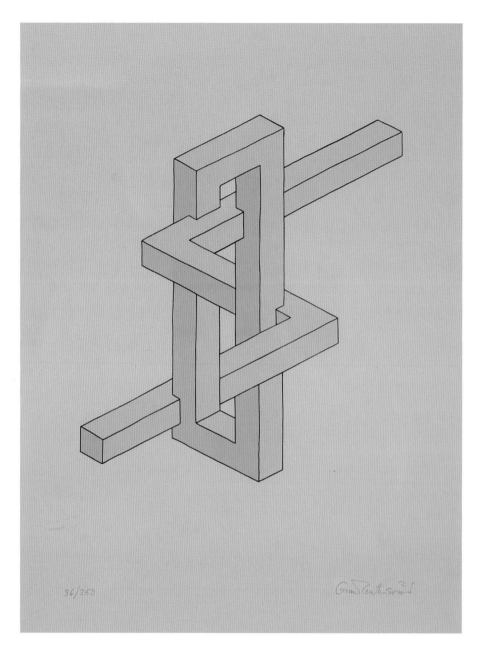

36/250

Oscar Reutersvärd

Impossible Figure

Reutersvärd typically created his impossible figures freehand with ink on Japanese rice paper. He drew without the aid of any rulers or other devices. This figure features two distinct impossible elements. First, the rectangle is twisted in an unnatural manner. Second, the bent line intersects the rectangle at a perpendicular angle at three separate points while appearing perfectly flat.

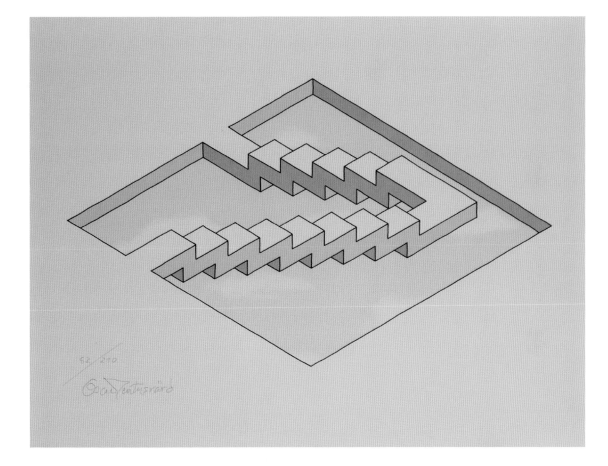

Oscar Reutersvärd

Impossible Window

In the 1980s, the Swedish government honored Reutersvärd by releasing a series of three postage stamps featuring his impossible figures. In addition to impossible figures, Reutersvärd also created many "impossible windows." In this example, a set of impossible stairs traverses from one edge of the window to another. Anyone ascending or descending these steps would find that they have neither gone up nor down upon reaching the top or bottom.

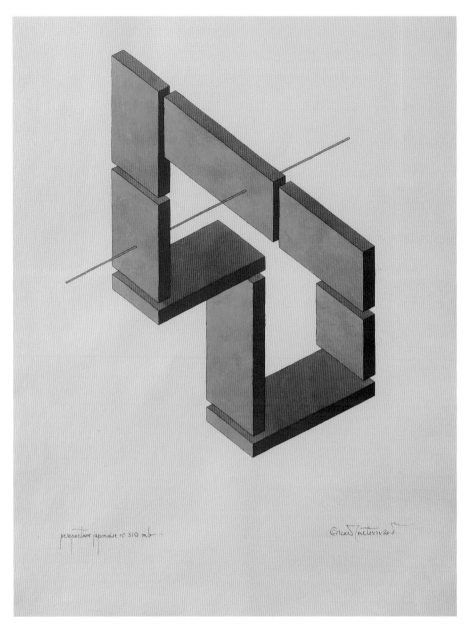

Oscar Reutersvärd

Perspective Japonaise no 310 mb

In the upper left-hand corner of this figure, the "bricks" are arranged in a manner that forms a right angle. Nevertheless, a rod appears to simultaneously pass through one of the vertical and horizontal bricks. This design gives the impression that each brick is located at a different depth on the paper, which would be impossible if they were indeed perpendicular to one another.

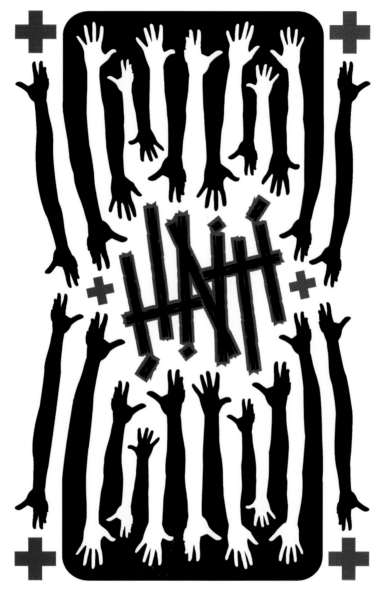

RONALD J. CALA II AND JOHN MOORE

Haiti, 2010

In the aftermath of the devastating 2010 earthquake in Haiti, a group of organizers created a fundraising effort called The Haiti Poster Project. According to their website, this project is "a collaboration of artists and designers from around the world, benefitting victims of the earthquake in Haiti." The money raised from the sale of the posters was donated to the charitable organization Doctors Without Borders. This poster features ambiguous outstretched arms in a black and white arrangement (designed by Cala) surrounding an ambigram (designed by Moore) that reads "Haiti" both right side up and upside down.

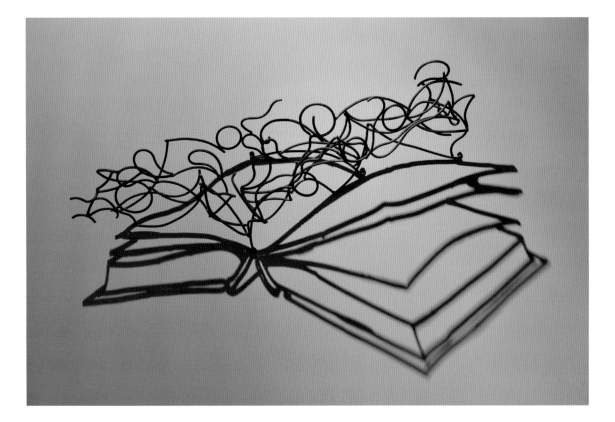

LARRY KAGAN

Great Book, 2004

A sculpture traditionally relies on mass to create its form. Larry Kagan's shadow art derives primarily from the novelty of the silhouette. Object/shadow sculptures, as Kagan refers to them, need both the solid and the shadow in order to exist. If the light source is moved to a different location, the image drawn by the shadow will not simply deform; it will completely disintegrate.

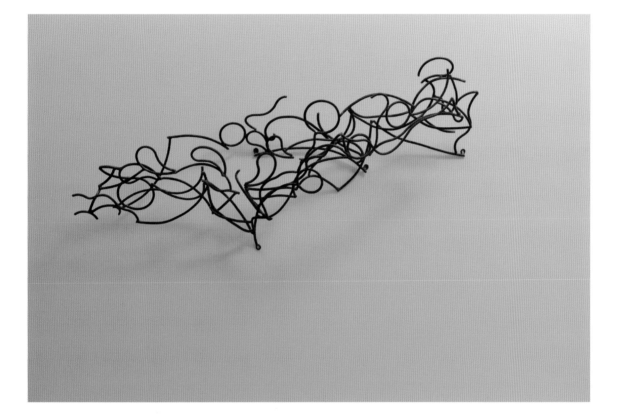

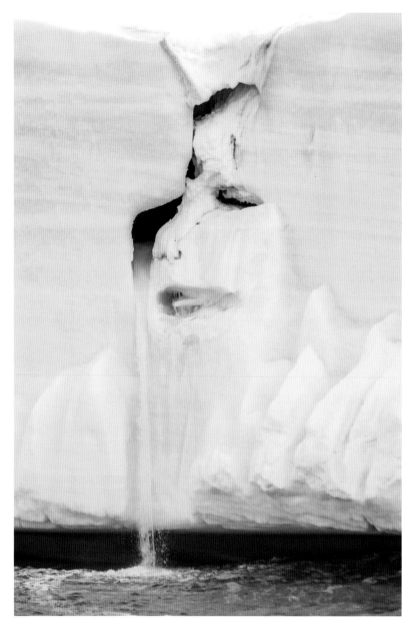

MICHAEL S. NOLAN

Mother Nature in Tears, 2009

This unaltered photograph was taken at the Austfonna ice cap located on the island of Nordaustlandet, an island in the archipelago of Svalbard, Norway. "When I took the image," notes the award-winning nature photographer, "I was struck by the unmistakable likeness of the face of a woman crying. In fact, once my mind locked onto that fact, it was hard to see any other pattern in the ice cap. I was moved to photograph this particular waterfall several different ways with a couple of different lenses. It was one of the best examples of a human likeness I have ever witnessed in nature."

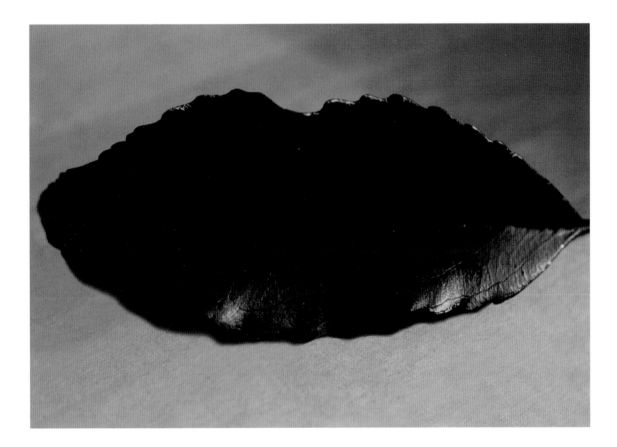

JOE BURULL

Leaf, 2002

California-based photographer Joe Burull captured this ambiguous photograph of a single leaf that also resembles the lips of a woman. In reference to his photography, Burull says, "Having a particular style has never appealed to me. I don't want to do the same thing over and over. Each subject tells me how to capture it. Walking the earth, I am moved at a feeling level and I shoot. That attraction is always familiar; the subject and how to capture is always different."

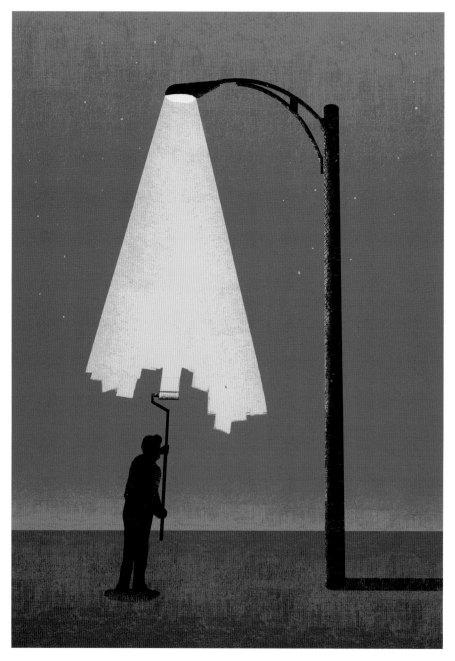

TANG YAU HOONG

Light Painter, 2011
Self-taught Malaysian illustrator Tang Yau Hoong loves to play with negative space and incorporate elements of illusion in his illustrations. In this whimsical and deceptive design, Yau Hoong shows a painter applying yellow paint to the night sky that then resembles a beam of light radiating from a street lamp.

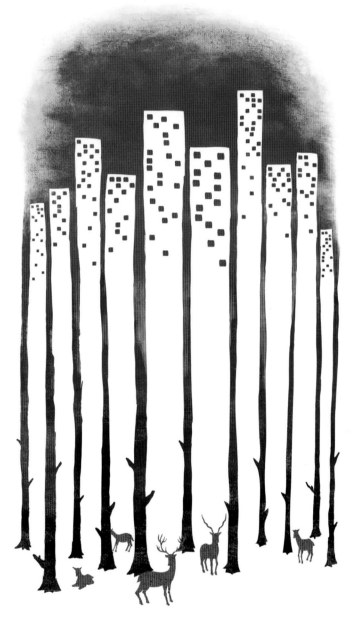

Tang Yau Hoong

Coexistence, 2009

In today's rapidly developing world, nature and urban expansion are frequently at odds with one another. The buildings toward the top of this design represent development, and the trees and wildlife at the bottom represent nature. Moving down (or up) from one element of this illustration to the other shows the two are ambiguously linked together. The space between the buildings forms the trunks of the trees, and the space between the trees forms the outlines of the buildings.

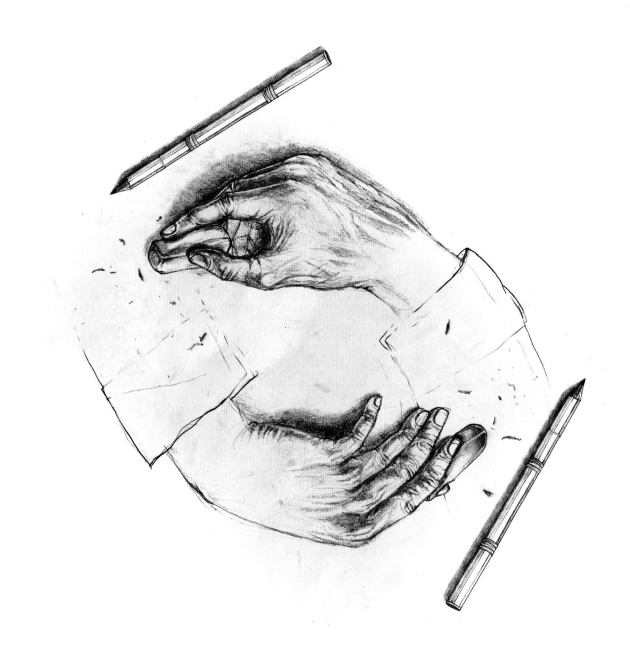

Tang Yau Hoong

Erasing Hands, 2008

In 1948, Dutch artist M.C. Escher released a paradoxical drawing called *Drawing Hands*. The print depicts two hands holding pencils seemingly drawing each other into existence on a flat sheet of paper. In this derivative work, the hands have put down their pencils and chosen erasers instead as their tool of choice. Each hand is simultaneously erasing the wrist of the other in a strange continuous loop.

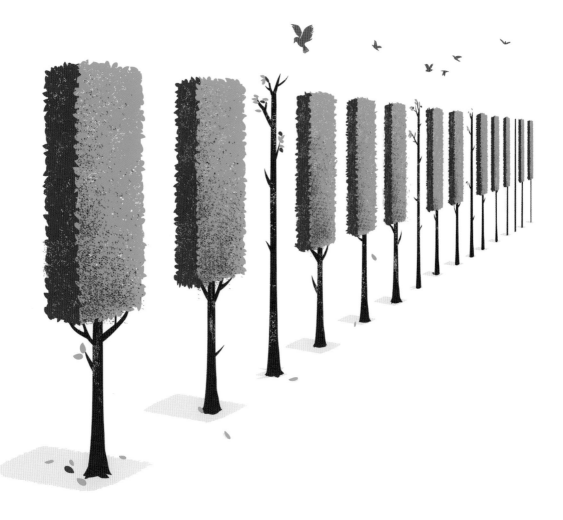

TANG YAU HOONG

Sound of Nature: Piano, 2011

As a graphic designer, Yau Hoong tries to convey messages visually through graphics that speak to the audience.
This simplistic illustration shows a solitary row of well-manicured trees with birds flying overhead. The trees—and
the space around them—resemble the keys of a piano, creating a scene with multiple meaning.

Arvind Narale

Lady Ironing Clothes, Kissing a Bird/Three Dogs and a Cat, 2002
Using ink and pencil on linen paper, Canadian artist Arvind Narale created this unique topsy-turvy drawing of a lady ironing her clothes while kissing her pet bird. The magic of this drawing is revealed when the entire image is flipped upside down. When rotated 180 degrees, the image transforms into one of three dogs and a cat. Narale says of his own work, "When two flawless images emerged on the two sides with a single set of lines, the artist in me felt really satisfied and one with the world."

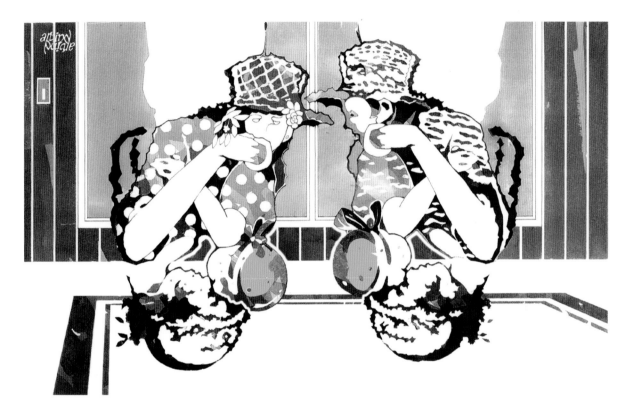

ARVIND NARALE

Women Conversing/Young Girls with Babies, 2002
Narale is an architect by profession, and attended Banff School of Fine Arts in Alberta, where he studied watercolor and oil painting. In the early 1970s, he conducted pen and ink sketching classes at Ryerson Polytechnical Institute in Toronto. The watercolor painting here features two women deep in conversation while sitting at a table. When inverted, the image becomes one of two young girls holding their babies.

Kaia Nao

Floating Star, 2012

Utilizing a peripheral drift effect, the pattern overlaying the blue star appears to be in motion. According to Kaia Nao, "The pattern is generated with a 'flow direction' determined by the offset white and black versions of the pattern behind it." This illusion was selected to be a finalist in the 2012 Best Illusion of the Year Contest hosted by the Neural Correlate Society.

KAIA NAO

Schmear, 2012

Bright flowing colors swirl around the page. As Nao recalls, "*Schmear* was the first of my images to be requested as a full-size print. It was interesting to see that the illusion was maintained and even enhanced when it was blown up to 32 by 42 inches. The print was originally intended to go in the customer's dining room, but the effect was strong enough that he wisely decided to hang it elsewhere."

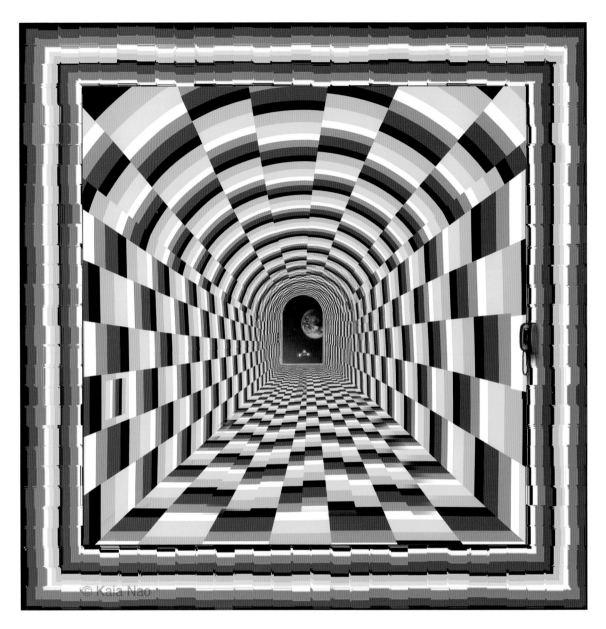

© Kaia Nao

KAIA NAO

Tunnel Vision, 2012

Nao cites the work and research of Japanese professor Akiyoshi Kitaoka as the primary inspiration for his illusions. The peripheral drift illusion is strongest for most people when their eyes move rapidly around the image. With "Tunnel Vision," Nao was attempting to add objects (the red telephone on the near right wall and the planet in the distance) to the image that would compel the viewer to move their focus from one part of the image to another.

MARK PALMER

Shark Attack, 2007

"My goal with this ambigram was to create an aggressively styled, clearly legible, and thematically consistent ambigram that would be showcased in an international ambigram challenge," says Mark Palmer. "The design has since drawn critical acclaim from some very notable artists and designers, has been featured in several books/publications, and is one of my favorite ambigrams."

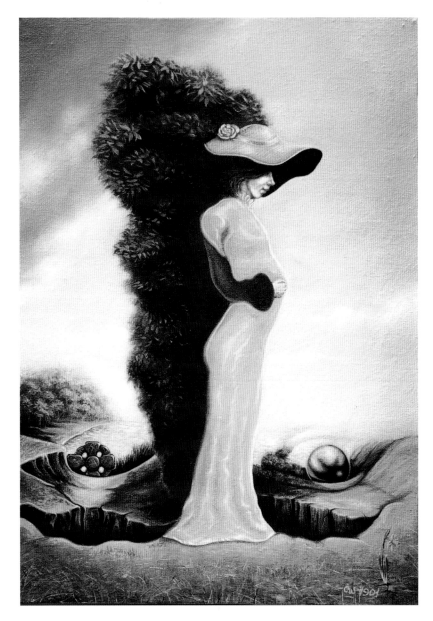

IGOR LYSENKO

Wilde Invisible Green, 2003

Many of Russian artist Igor Lysenko's paintings contain hidden secrets or double meanings. Here, a pregnant woman (representing hope) wearing a yellow hat and dress stands in front of a tall green bush. The hidden secret is revealed when this image is turned upside down. Once rotated 180 degrees, a portrait of writer and poet Oscar Wilde can be found. Lysenko also notes that the title of this painting contains a bit of word play and can be divided into two parts. The first part, *Wilde Invisible*, refers to the hidden portrait of Oscar Wilde. The second part, *Invisible Green*, refers to the name of a shade of the color green.

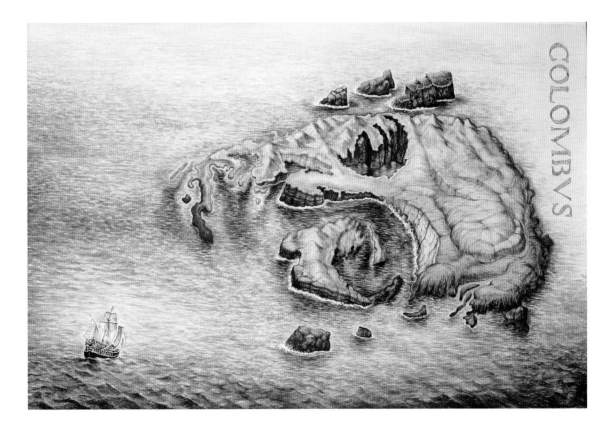

Igor Lysenko

Archipelago of Columbus, 2012

A ship, the *Santa Maria*, sails toward a series of undiscovered islands in the middle of the ocean. By rotating the image 90 degrees counterclockwise, a portrait of explorer Christopher Columbus is revealed. For the basis of this image, Lysenko drew inspiration from a 16th-century portrait of Columbus by Italian historian and biographer Paolo Giovio.

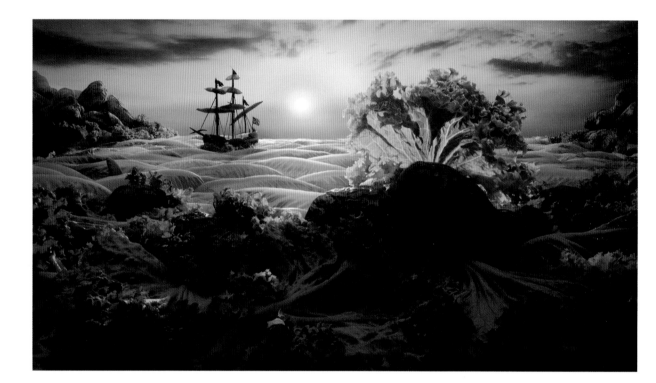

CARL WARNER

Lettuce Seascape, 2012

The Lettuce Seascape, a single photograph made entirely of food items, was filmed in the making by a children's TV show on BBC called *Totally Rubbish* aimed at 9- to 13-year-old kids. The idea was born on the back of a single idea about a lettuce leaf looking like a splash of water. Carl Warner then developed this into a wider seascape with rocks and a sailing boat to accompany the splash idea, and to form a fun image to engage children.

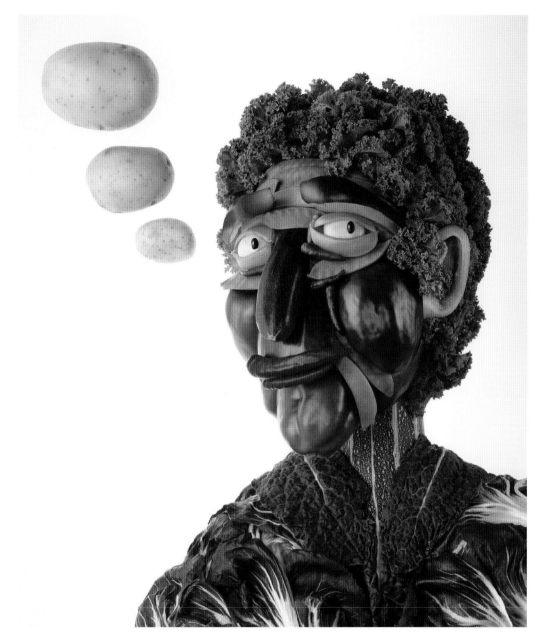

Carl Warner

Vegehead, 1999

Inspired by Italian painter Giuseppe Arcimboldo, *Vegehead* was commissioned by an advertising agency to promote a campaign about thinking differently. The entire image was built in camera, and no retouches or other alterations were made to this photograph. Warner uses this image as a self-portrait on letterhead and social media profiles so that he does not have to provide an image of himself.

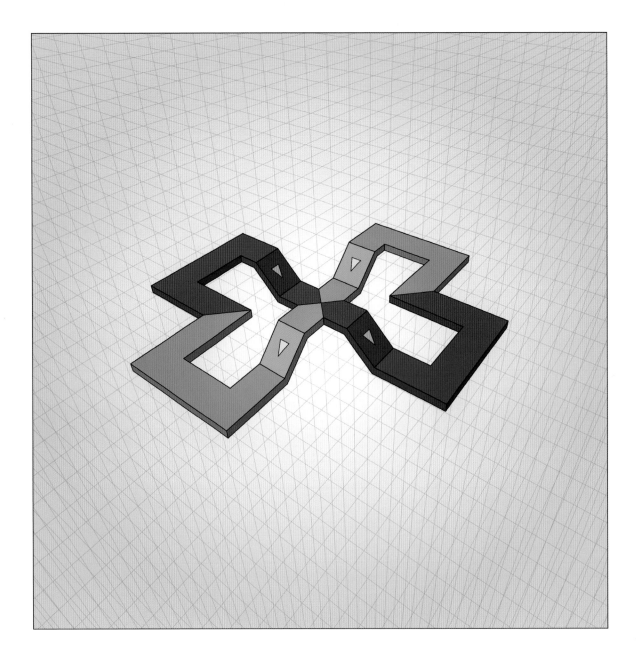

ANDREAS ARONSSON

Infinity, 2013
Andreas Aronsson is a computer programmer by day, and an artist, among other things,
by night. He creates impossible figures to challenge his mind and feed his creative side.
Follow the arrows down the slopes and you will forever travel downhill.

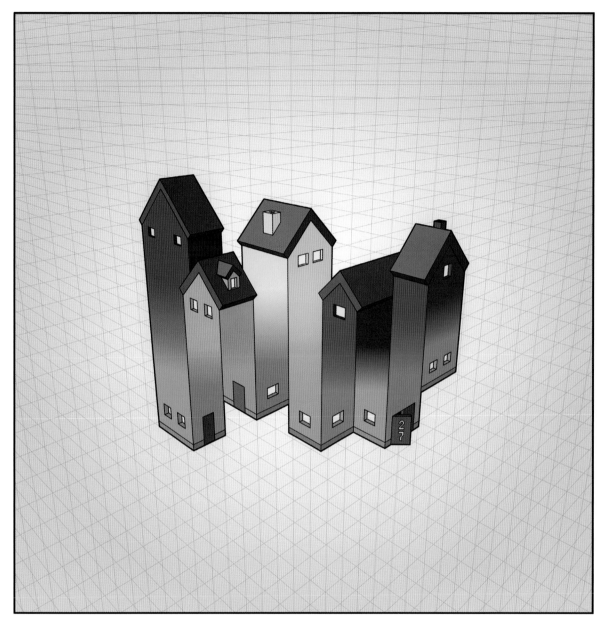

ANDREAS ARONSSON

Town, 2013

Which way do the walls on the houses in this town face? Depending on where you look, you may find yourself coming up with different answers. If you cover the bottom half of this image, the building tops look perfectly normal. If you cover up the top half, the bottoms of the buildings also look normal. When both halves are viewed simultaneously, this town and its impossible constructions appear architecturally challenged.

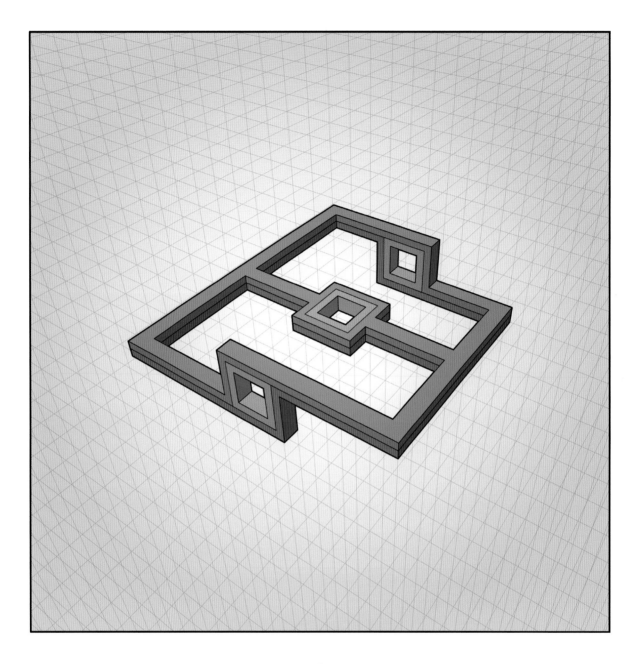

ANDREAS ARONSSON

Hoops, 2012
If you travel clockwise around this perplexing figure, you will go down forever. If
you move in a counter-clockwise direction, you will travel up forever. The hoop
in the center, however, makes this object appear entirely flat.

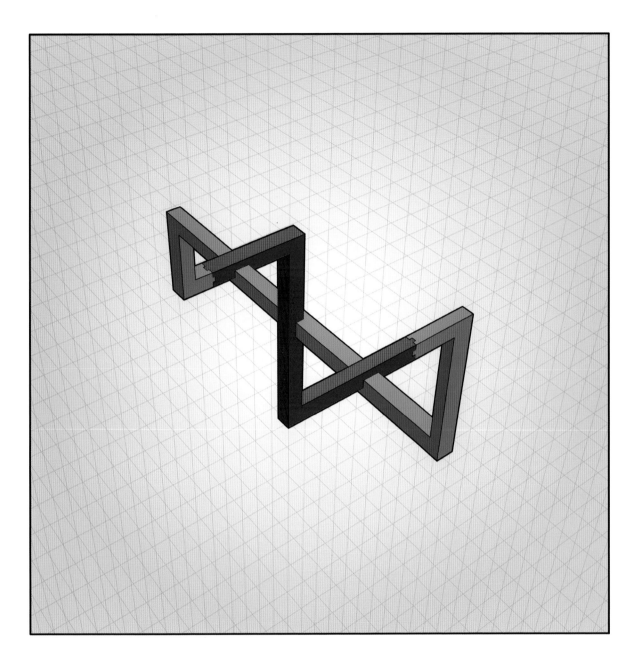

ANDREAS ARONSSON

Zigzag, 2011
This twisted figure is basically a broken tribar (or impossible triangle). If you follow the figure in one direction you will continuously go up or down, as well as forward or backward.

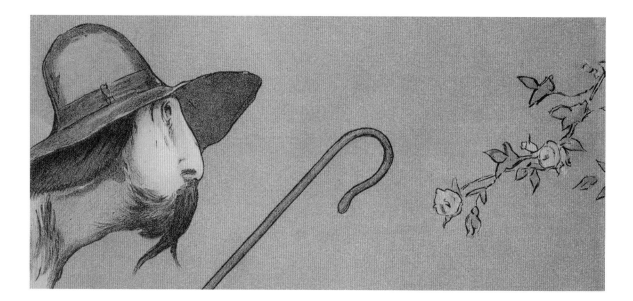

PETER NEWELL

Shepherd/Goat, 1894

In the late 19th century, American illustrator Peter Newell released two novelty children's books titled *Topsys and Turvys* and *Topsys* and *Turvys Number 2*. These books featured pictures and rhymes that could be viewed and read both right side up and upside down. An enchanting transformation occurs when any page is inverted. The following rhyme accompanies this image in the original book: "This shepherd thought poetic thoughts as by the flocks he sat; But while he wrote his verses, the goat fed on his hat."

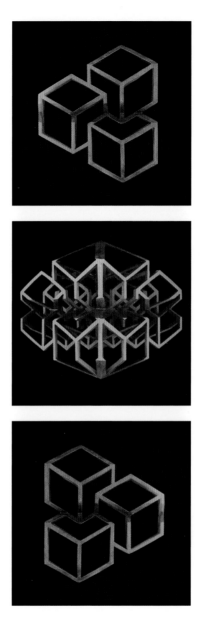

GUIDO MORETTI

Three Impossible Cubes, 2005

Italian sculptor Guido Moretti created this sculpture as a tribute to Oscar Reutersvärd. The three photographs presented on this page represent the same sculpture viewed from three different angles. When viewed from a specific vantage point on the left or right, the sculpture appears to be a series of three impossible cubes. The sculpture looks quite a bit different, however, when it is viewed from any other angle. The center photograph above shows what the sculpture looks like when viewed from a spot directly between the two points that reveal the cubes.

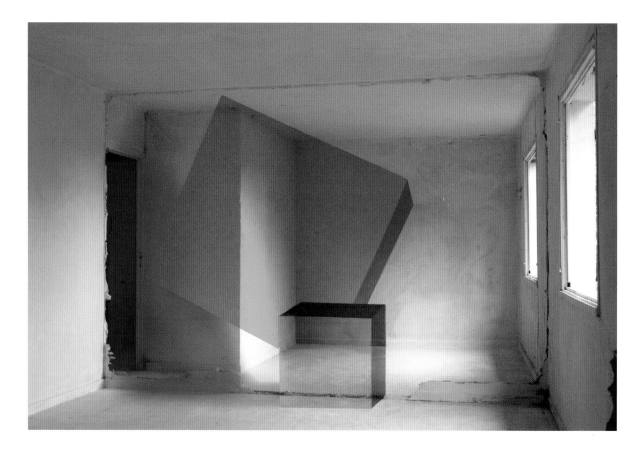

ALEXIS FACCA

Green Sqwear, 2010
This anamorphic 3D cube was created for an online fashion store named Sqwear.fr. The cube was painted
on six different walls (see facing page for detail), and required fourteen cans of spray-paint.

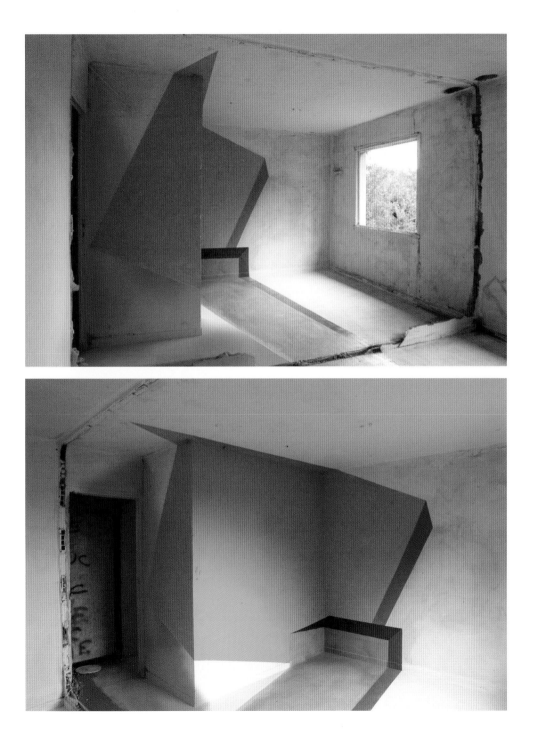

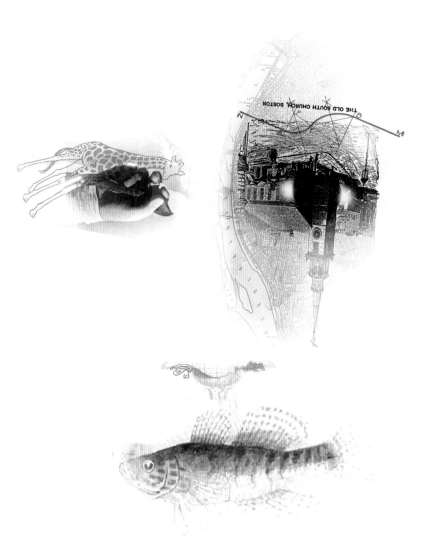

JULIE HELLER

A Bird in Hand, 2008

By arranging random images of a bird, a fish, a giraffe, a hand, a church, and a steeple in the form of a digital collage, artist and designer Julie Heller has rendered a portrait that resembles a human face. "With an extra-heavy dose of the primordial urge to recognize the human face, I see faces and their component parts in almost everything I see," Heller said in an artist statement. When viewed from a distance, the face in this collage is even more recognizable.

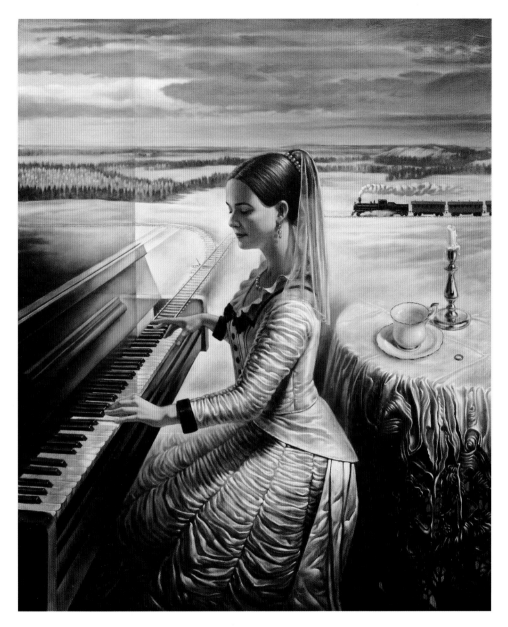

MICHAEL CHEVAL

Anna, 2010

The artist dedicated this painting to the novel *Anna Karenina* by Leo Tolstoy. In the novel, the title character throws herself in front of a train after a failed love affair. As such, the painting reflects both loneliness and the "geometry of mistakes and their consequences." The rails transform into piano keys, symbolizing how enjoyment can quickly turn darker, leading to anguish and death. The piano and table dissolving into the snowy landscape of the Russian winter add to the coldness and loneliness of the scene.

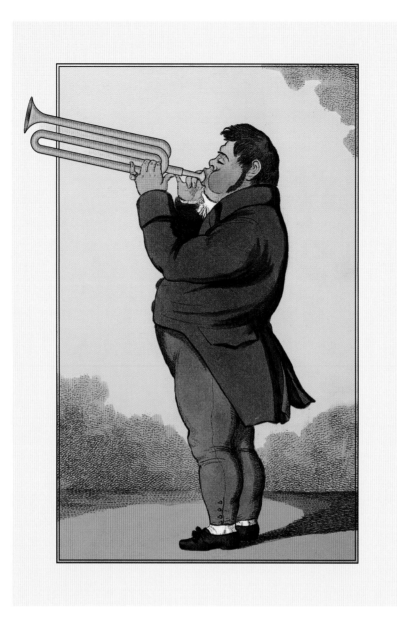

GIANNI A. SARCONE

Trumpet Player, 2009

This trumpeter looks to be struggling to play his instrument. He is giving it his best shot, but no music is coming out and his cheeks have turned red in the process. Examining the brass tubing in greater detail reveals there is good reason for his struggles. Following the tubing from his lips reveals that it is not continuous, and therefore an impossible instrument.

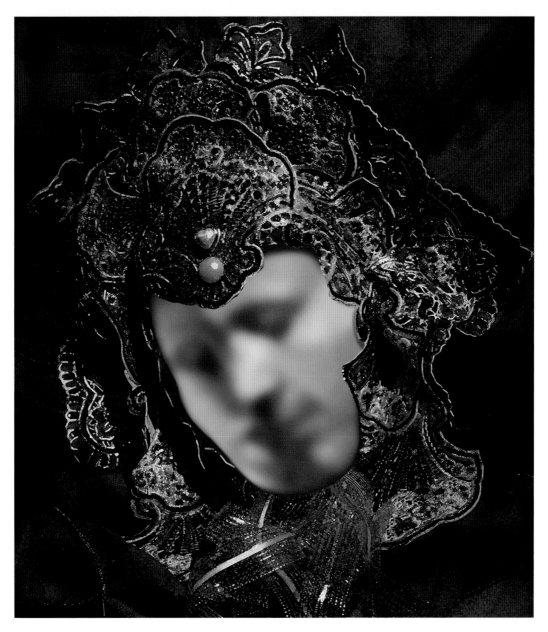

Gianni A. Sarcone

Mask of Love, 2010

When viewing this Venetian mask for the first time, most people notice a single, slightly blurry face that appears to be wearing the mask. Upon closer inspection, however, there are actually two faces within the mask's outline. A woman (on the left) and a man (on the right) can be seen kissing one another. Once the viewer discerns these two individual faces within the space of the mask, their brain will 'flip' between two possible interpretations of what lies inside of the mask. This illusion was a finalist in the 2011 Best Illusion of the Year Contest hosted by the Neural Correlate Society.

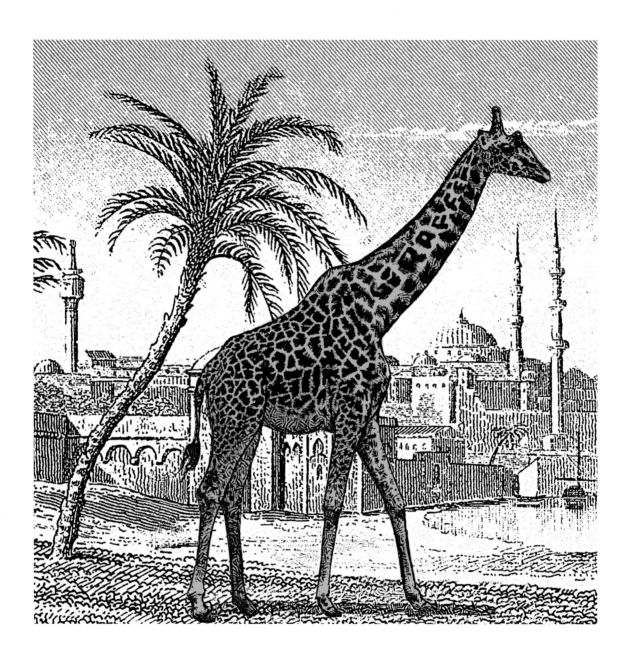

GIANNI A. SARCONE

Hidden Giraffe, 2006
A very tall giraffe can be seen standing in the foreground of this illustration. Another giraffe (much smaller
than the visible one) can be found hiding somewhere else in this image. See page 223 for a hint.

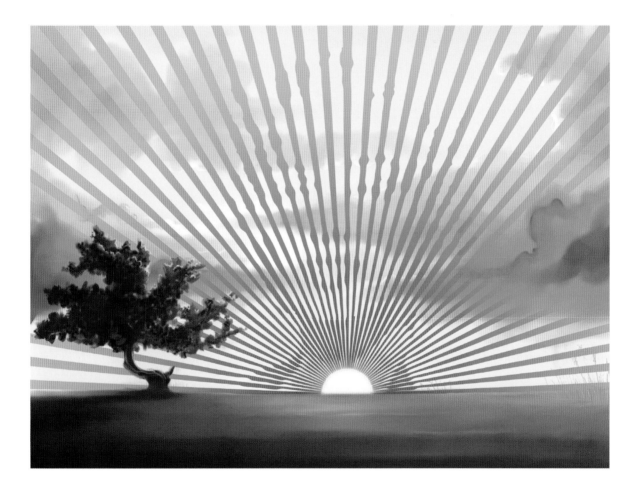

GIANNI A. SARCONE

Marilyn Sunset, 2009

This is no ordinary sunset. A very unique and famous face can be found hiding somewhere in this image. The face of the late actress, model, and singer Marilyn Monroe can be seen among the rays emanating from the sun. If you have difficultly spotting her, try viewing this image from a distance and/or squinting your eyes.

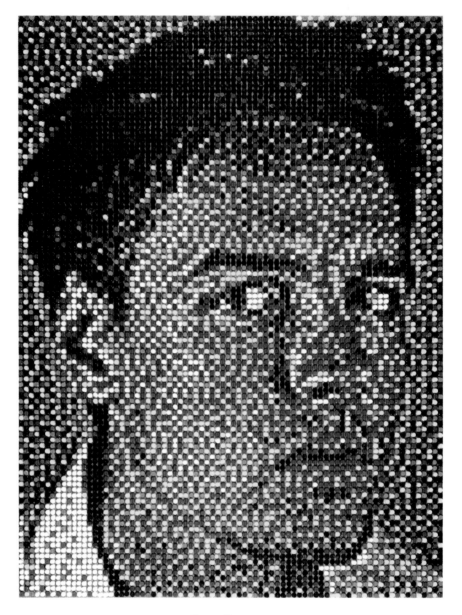

ERIC DAIGH

Self Portrait II, 2009

Here, a portrait of the Northern Michigan artist has been reconstituted in mosaic format with 8,500 red, blue, yellow, black and white pushpins on cork board. While discussing his pushpin portraits, Daigh offers the following: "If we force an image to be less, and to have to do more with less... then what happens? And what do we learn about ourselves? When an image is right on the edge of not being able to convey what that subject is or who that subject is, but then still does, that's my sweet spot. That's exactly what I'm after and where I'm trying to exist."

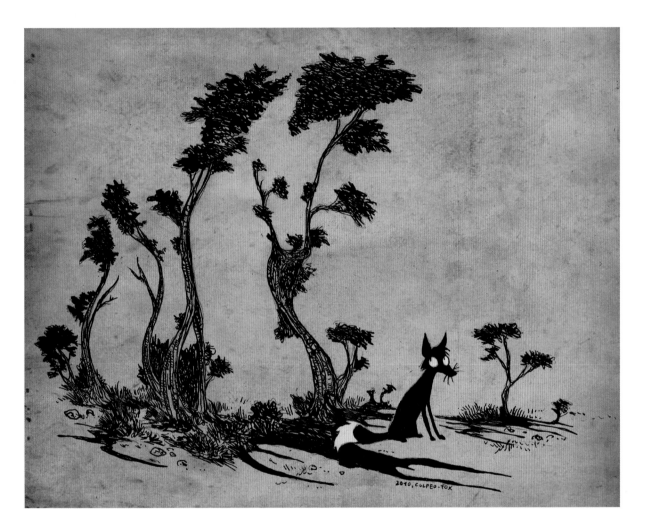

Culpeo Fox

Haunted, 2010

As a lone fox sits in the woods, he cannot help but get the feeling that he is being watched. When he looks over his shoulder, all he sees are trees and plants. Is he paranoid, or is the forest haunted? "The world is full of wondrous things that seem like signs from a hidden world," comments the artist. "Just open your eyes and you might catch some."

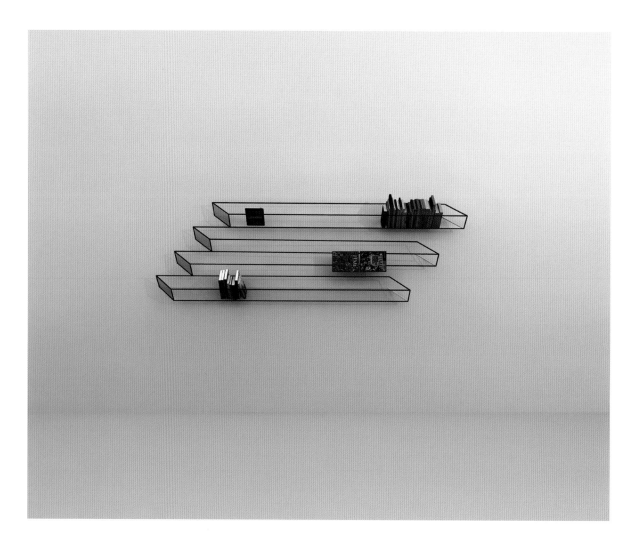

John Leung

"Bias of Thoughts" Bookshelf, 2013

Inspired by the famous 2D drawing of the optical illusive bookshelf, a 3D structure is translated and the "Bias of Thoughts" bookshelf is formed. It can be used for shelving books and iPads, as well as hanging magazines. Visually, the optical illusion serves as a reminder that, whenever one picks up a medium, ideas can be misinterpreted when passed from one end to the other.

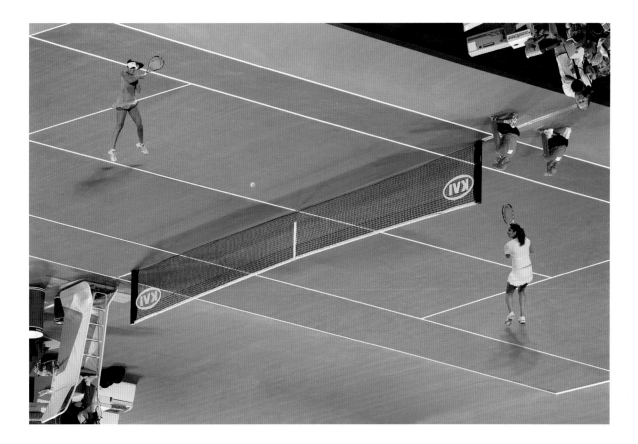

MICHAEL KAI

This Side Up – Tennis, 2008

The photographs used to compile this image were taken at the 2008 Australian Open. The photographer had to create a library of different players to ensure he would have enough options for this final image. He ended up using images of the players Ana Ivanovic and Sania Mirza for the final composition. The sponsor's name on the net was altered to represent his last name. Michael Kai notes, "This body of work features optical illusions, designed alternatives, and manipulated room perceptions. The spatial arrangement of the images can be interpreted in contradictory ways—a phenomenon based on the way we can perceive two-dimensional images as being three-dimensional."

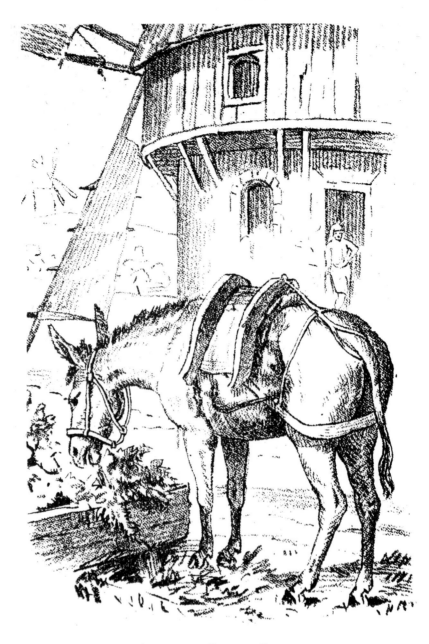

AMERICAN PUZZLE CARDS

The Miller, 1880

Puzzle cards like this one and the one on the facing page were frequently used as advertising and promotional items during the late 19th and early 20th centuries. The back of the cards told viewers that if they had trouble finding the solution to the puzzle, they could come into the store and the answer would be revealed. In this illusion, the miller is hiding. Do you see him? The miller is not the individual that can be seen in the doorway of the windmill. See page 223 for the solution.

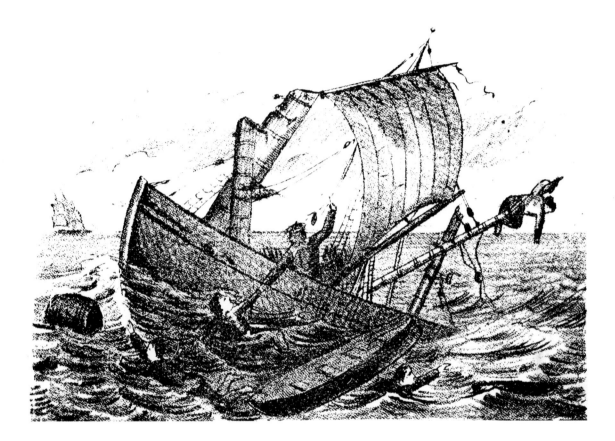

American Puzzle Cards

H.M.S. Pinafore, 1880

A ship, the H.M.S. *Pinafore*, has hit a rough patch of sea and is taking on water. As it begins to sink, the crew scrambles to find the captain. Do you see him in this chaotic scene? See page 223 for the solution.

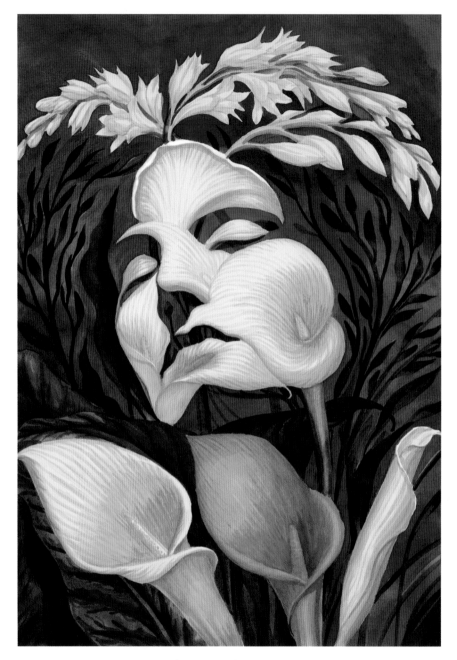

OCTAVIO OCAMPO

Ecstasy of the Lilies

Octavio Ocampo is one of Mexico's most prolific artists. He describes his painting style as "metamorphic," where the individual components that make up the painting come together to form a larger image. In this example, Ocampo has painted a group of white lily flowers that form the figure of a woman.

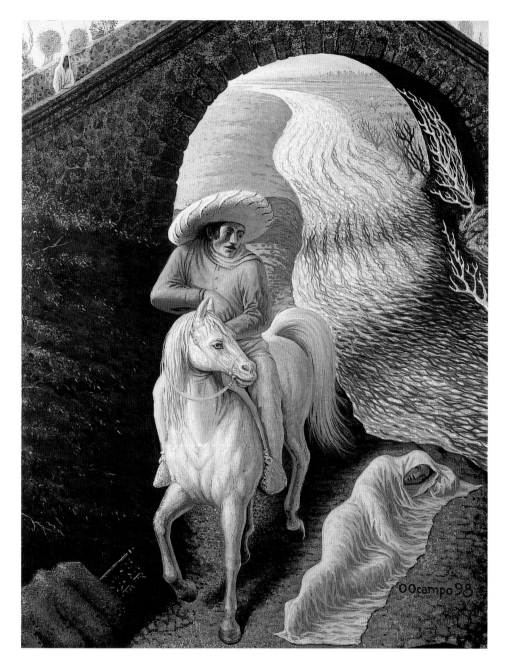

Octavio Ocampo

Old Man and the River, 1998

Ocampo has been commissioned to create metamorphic portraits for President Jimmy Carter, Jane Fonda, Cher, and Cesar Chavez. In this painting, a man on horseback travels past a woman lying next to a small river. All the while, the presence of an old man can be felt watching over the entire scene.

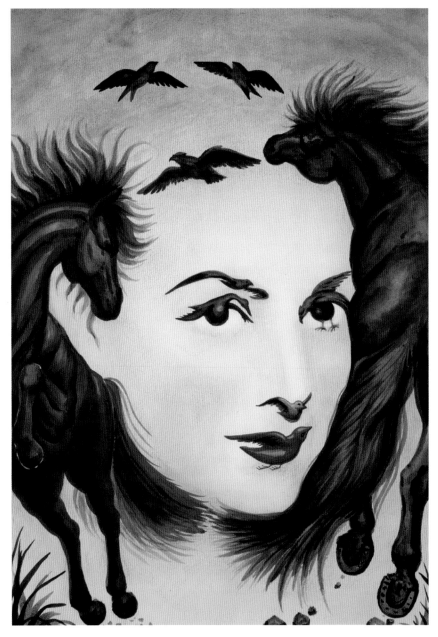

OCTAVIO OCAMPO

Nature's Spirit

Galloping horses and flying birds arrange themselves in such a way that the portrait of a young woman is revealed. While Ocampo has many other talents, he has dedicated himself exclusively to painting and sculpture since 1976. Ocampo currently works and resides in Tepoztlan, Mexico. Located just north of Mexico City, Tepoztlan is considered one of the most magical places on earth.

Michael Cheshire

42 Triangles, 2010

This wooden sculpture appears to be spherical in shape, but is perfectly flat. The artist used three different types of wood in its construction: Queensland maple, silver ash, and Queensland walnut. The color differences in the various wood types help to give the impression that this object is three-dimensional.

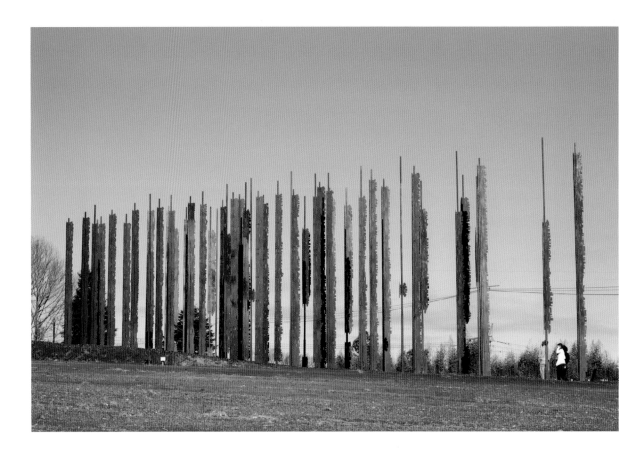

MARCO CIANFANELLI

Release, 2012

At the site in South Africa where Nelson Mandela was arrested by apartheid police officers in 1962, fifty laser-cut steel columns rise into the air. The columns range in height from 21 to 31 feet, and appear jagged and randomly placed. The approach to the site leads visitors down a path toward the columns, where, at a distance of 115 feet, they take on an entirely new meaning. At this distance, they line up perfectly to form a flat image of a profile of Mandela looking to the west. In the official press release announcing the sculpture, Marco Cianfanelli commented, "The fifty columns represent the fifty years since his capture, but they also suggest the idea of many making the whole; of solidarity. It points to an irony as the political act of Mandela's incarceration cemented his status as an icon of struggle, which helped ferment the groundswell of resistance, solidarity, and uprising, bringing about political change and democracy."

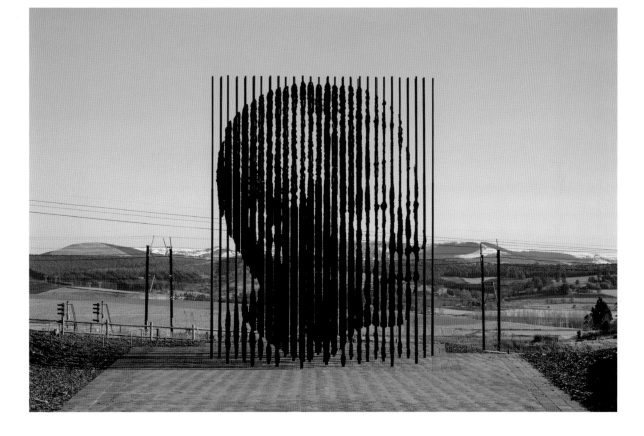

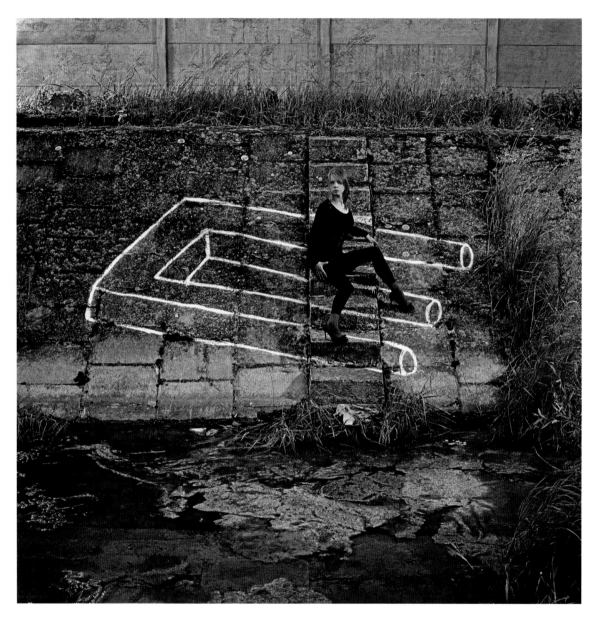

Bartek Hlawka

Impossible Trident Anamorphosis, 2007

This photograph of a woman perched on an impossible trident was taken by Bartek Hlawka as part of a project while he attended the University of Arts in Poznan, Poland. This photograph, along with five others in the series, was inspired by the works of Felice Varini and Georges Rousse. One of the first known publications of the impossible figure featured here was on the cover of an issue *Mad Magazine* alongside its mascot, Alfred E. Neuman, in 1965.

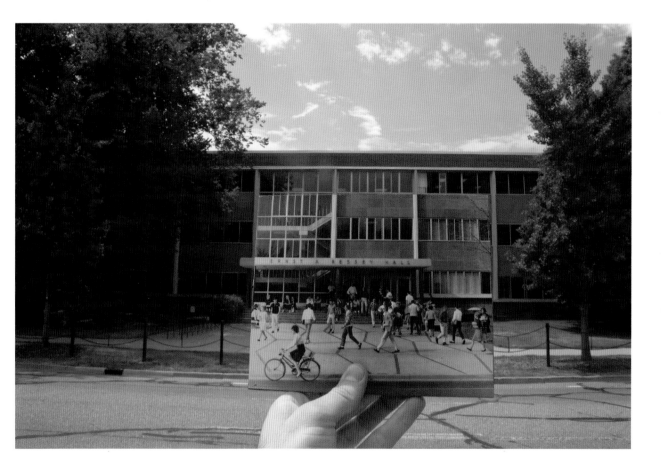

Michael Samsky

MSU Then & Now, 2012

This double photograph of Bessey Hall, then (in the 1960s) and now, merges the past and the present. Bessey Hall sits on the campus of Michigan State University in East Lansing, Michigan, and houses classrooms, the Learning Resources Center, Resource Center for Persons with Disabilities, and more. Founded in 1855, Michigan State University was the prototype for sixty-nine land-grant institutions established under the Morrill Act of 1862. Today, more than 48,000 "Spartans" from all 50 states and more than 130 countries attend the university.

JOHN CRAIG

Hidden Bunny, 1989

Most people have no trouble seeing the two plants in this engraving-style illustration. If you happen to notice something else hiding in this bistable picture, then nothing is wrong with your eyes. This is a variation of the Rubin vase (also called the Rubin face or figure-ground vase) developed by Danish psychologist Edgar Rubin in the early 20th century. This illusion was created for an advertising campaign promoting the State of Maryland.

THOMAS BARBÈY

Piano Peace

Thomas Barbèy has a collection of photographs taken over a period of twenty years. By combining multiple photographs from his archives, he creates unique and surreal scenes. When creating an illusion image, he makes sure it passes what he calls the "So, what?" test. If a combination of two or more photographs put together does not touch him in a significant way or have a deeper meaning, then he scraps the idea and starts over.

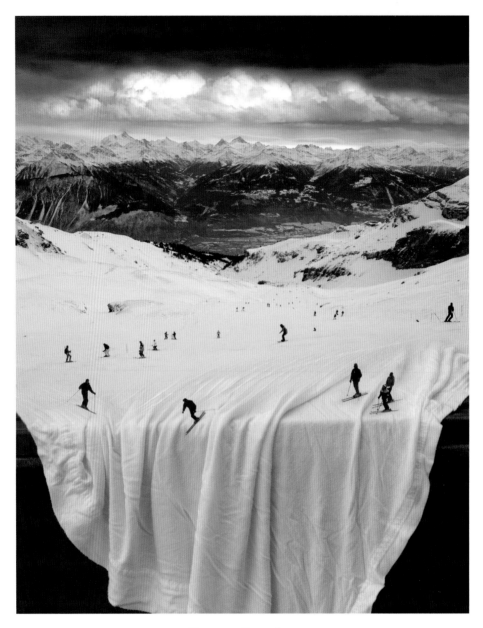

Thomas Barbèy

Oh Sheet!

While skiing off the designated trail area in Verbier, Switzerland, Barbèy noticed an edge and thought it looked like it would be fun to jump over. His friends, ready to head in for some lunch, called his name and distracted him from doing so. Before following his friends, he stopped at the edge and took a look over it to see what he would be missing out on. To his astonishment, over the edge was a very steep cliff with a chalet located directly at the bottom. "My friends saved my life that day," recalls Barbèy.

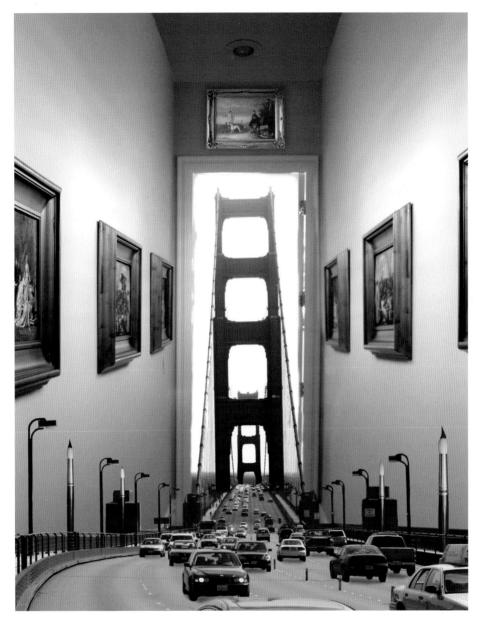

THOMAS BARBÈY

Drive-Thru Gallery

Inspiration for this work came in the form of a very long wait. When a traveling Tutankhamen exhibit came to London a few decades ago, Barbèy waited in line for eight hours to see it. After the lengthy wait, he found that he was rushed though the exhibit a lot faster than he would have preferred. From the experience, he concludes that "... we are living in a fast pace world where people aren't taking the time to enjoy special moments, such as looking at art in the museums, or even taking the time to notice all the beautiful things that surround you."

NEVIT DILMEN

Fraser Spiral, 2012

This image appears to be a spiral, but in reality is a series of concentric circles. Choose any point on the image and follow the circle around to confirm this for yourself. This type of figure is also known as a Fraser spiral, named for British psychologist Sir James Fraser, who first described the effect in a 1908 paper titled "A New Visual Illusion of Direction."

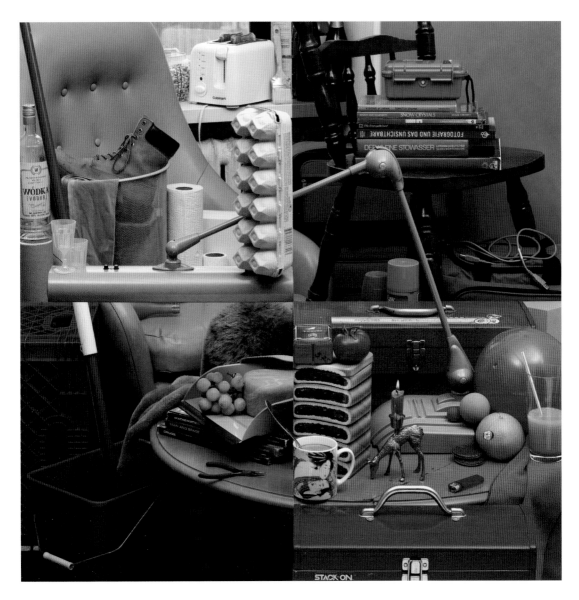

BELA BORSODI

VLP, 2011

There is something remarkable about this photograph: while it looks like a series of four individual square photographs, it is actually one single image. Several items in this photograph, such as the blue chair and the desk lamp, can be seen crossing multiple quadrants. New York-based photographer Bela Borsodi recalls, "I simply began to arrange objects in my apartment in front of the camera and tried out all sorts of things until they developed a structure I could follow and then things fell in place. As I progressed it was fun to see the chaos in my apartment, but seen through the eye of the camera, all was arranged to give the desired illusion of order." This photograph was created for the cover photo of the music CD, *Terrain*, by the band VLP, released by Idyllic Noise.

Roger Shepard

Getting Down to Business

Before teaching at Stanford University for nearly thirty years, psychologist and cognitive scientist Roger Shepard worked at Bell Laboratories and earned a Ph.D. from Yale University. This ambiguous drawing, alternately titled "Time-Saving Suggestion," can be viewed in one of two ways: Either as a series of blue arrows pointing left and right, or as gold figures (that Shepard describes as "hurriedly descending commuters") walking down a stairway.

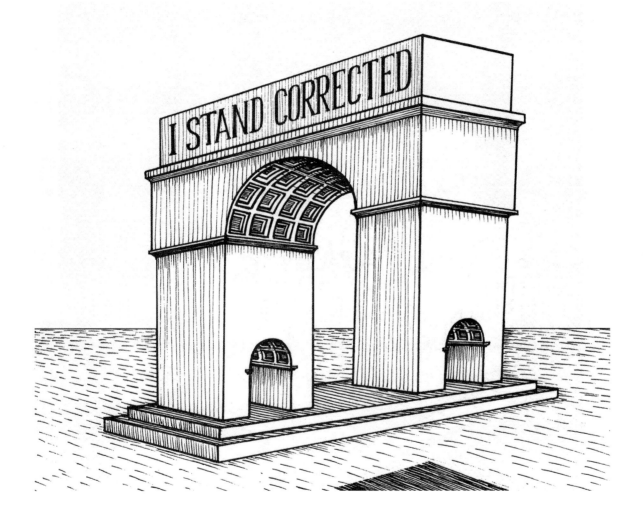

ROGER SHEPARD

I Stand Corrected

This oddly twisted arch presents a three-dimensional structure that would appear to be impossible to construct anywhere other than on a sheet of paper. Shepard, however, feels that this arch is highly improbable, not absolutely impossible. In 1990, Shepard published a book titled *Mind Sights* that featured a collection of visual illusions and other anomalies.

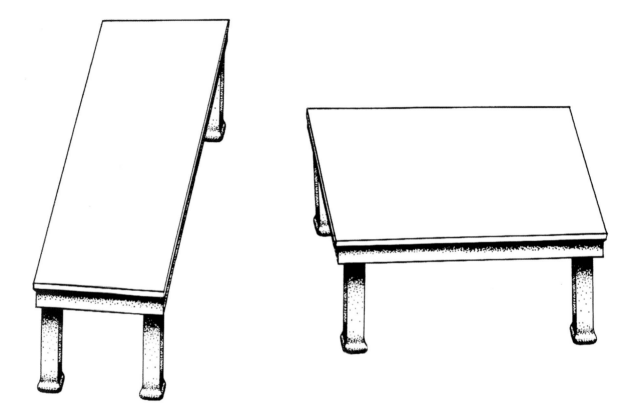

ROGER SHEPARD

Turning the Tables

Although they look completely different, the tops of these two tables are identical in size and shape. Shepard frequently used a transparency of this illusion in his lectures. He had a separate transparent slide with a red outline of a parallelogram the same shape as each of the tabletops. He would then move the parallelogram back and forth to demonstrate that the tops of the tables were indeed identical. Even after seeing this, many students still would not believe it, and were certain that there was some sort of trick being employed.

RADEK OSSOWSKI

The Tree of Life, 2011

A lonely tree stands alone as the sun begins to set. Upon closer inspection, however, it is revealed that
this is no ordinary tree. The Tree of Life is called so for a reason. Can you figure out why?

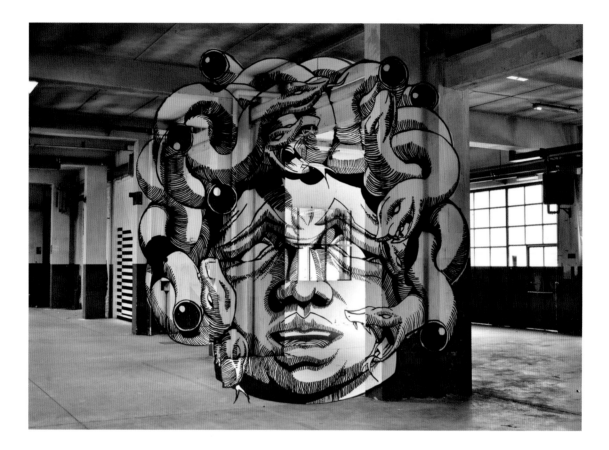

Ninjai and Mach505 of Truly Design

Anamorphic Medusa, 2011

According to Greek mythology, Medusa was a monster who had snakes on her head instead of hair. If someone were to look directly at her, they would instantly turn to stone. The hero Perseus was able to defeat Medusa by looking at her image indirectly through the reflection of his polished shield, thereby avoiding her wicked spell. The artists from Truly Design, based in Torino, Italy, created this anamorphic painting that can also only been seen safely from a certain viewpoint. If you move from the fixed viewing position (see facing page), the image becomes distorted, spanning the floor, ceiling, walls, and columns.

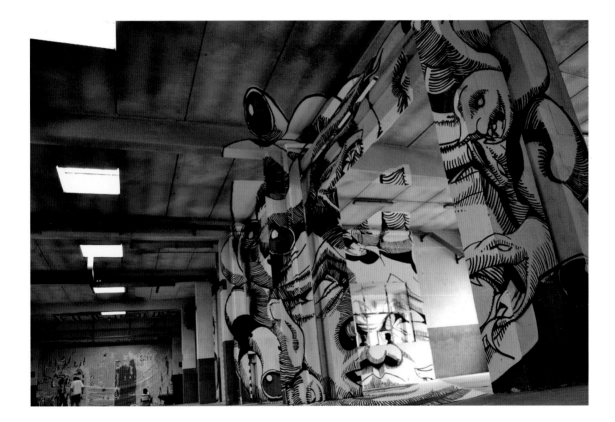

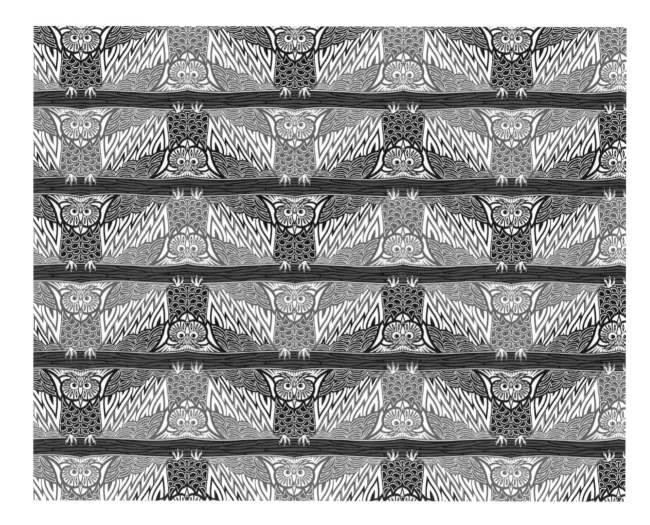

NIKITA PROKHOROV

Owl Tessellation, 2012

A tessellation is an image that repeats the same shapes over and over again, covering a plane without overlaps or gaps. This type of pattern was frequently employed by Dutch artist M.C. Escher, who was fascinated by their symmetry. Here, graphic designer Nikita Prokhorov has designed a pattern with no gaps or overlaps featuring a pattern of upside-down and right-side-up owls.

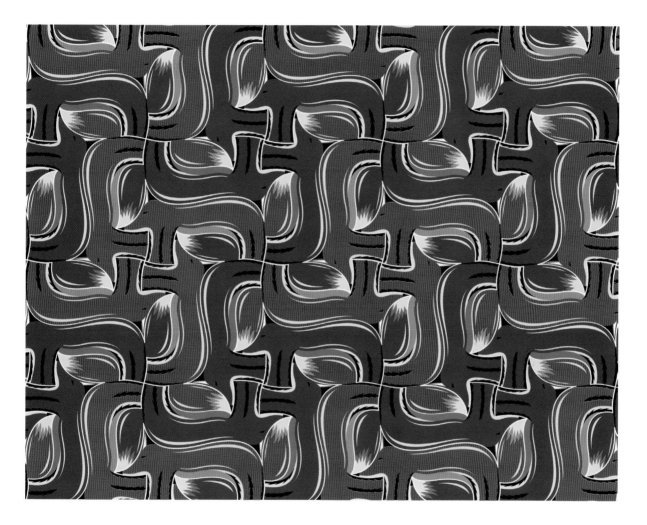

NIKITA PROKHOROV

Fox Tessellation, 2012

This tessellation pattern features a pattern made from orange and gray foxes. Prokhorov was inspired to design this image after flipping through a Russian children's book that featured many fantastic animal illustrations. After seeing an illustration of a fox from the side perspective, he immediately knew it would provide a good basis for a tessellation pattern.

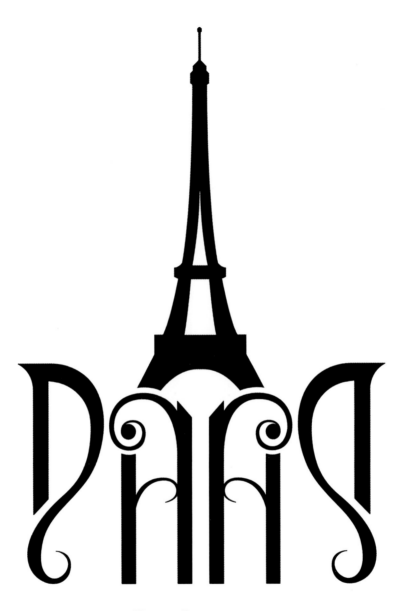

Nikita Prokhorov

Paris Ambigram, 2010

This ambigram design features reflected (or mirror) symmetry. The left and right side of the image are mirror opposites of one another. Prokhorov was inspired to design this ambigram after seeing the Eiffel Tower in the background of an old French movie. During the movie, he marveled at the symmetry and balance of the tower, and naturally wanted to see if this would translate well into letterform. This design is featured in Prokhorov's 2013 book, *Ambigrams Revealed: A Graphic Designer's Guide to Creating Typographic Art Using Optical Illusions, Symmetry, and Visual Perception*, published by New Riders.

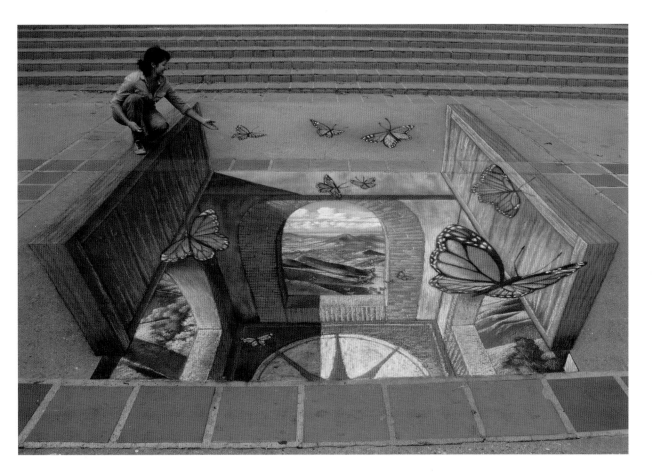

TRACY LEE STUM

Butterflies over San Luis, 2011

In an artist statement, Tracy Lee Stum says, "I draw things with chalk pastels on pavement, streets, plazas, or sidewalks in urban public areas. I have a passion for manipulating 2D surfaces to reveal an unlikely alternative in 3D, typically designing and creating interactive images which invite the viewer to become part of my imagined world." Here, Stum has opened up an imaginary doorway in the pavement, revealing a room full of butterflies with arched windows and majestic views of a rolling fantasy landscape.

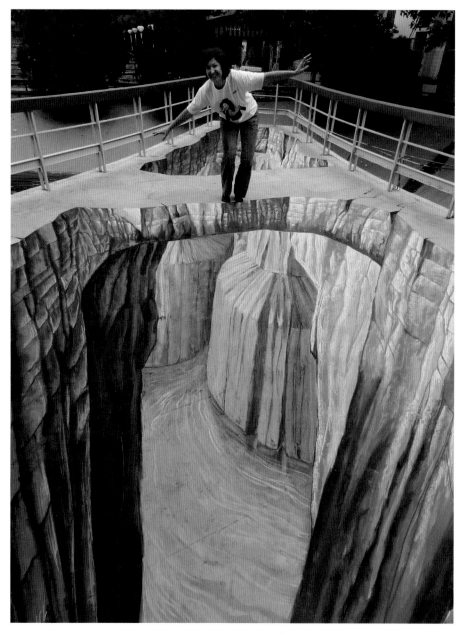

TRACY LEE STUM

Nandan Center, Kolkata, India, 2012
This street painting was created as a spontaneous, on-the-spot image designed during a demonstration workshop hosted by the artist. It took two artists about six hours to complete it. Stum says that she selected the site because she thought it was an "interesting space to play with."

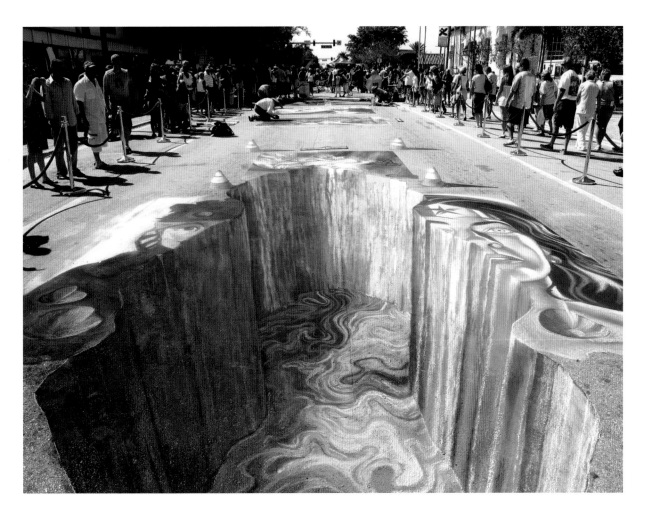

TRACY LEE STUM

Hot Asphalt, 2011

Created at the 17th Annual Lake Worth Street Painting Festival in 2011, this 3D chalk painting shows three traditional-style street paintings melting into a very hot street. As the paintings appear to dissolve from the heat, they begin to meld together in a pool of swirling colors. "I know it's okay for things to fall apart, melt away, merge, morph and be reborn," says Stum. "My paintings have taught me that over the years."

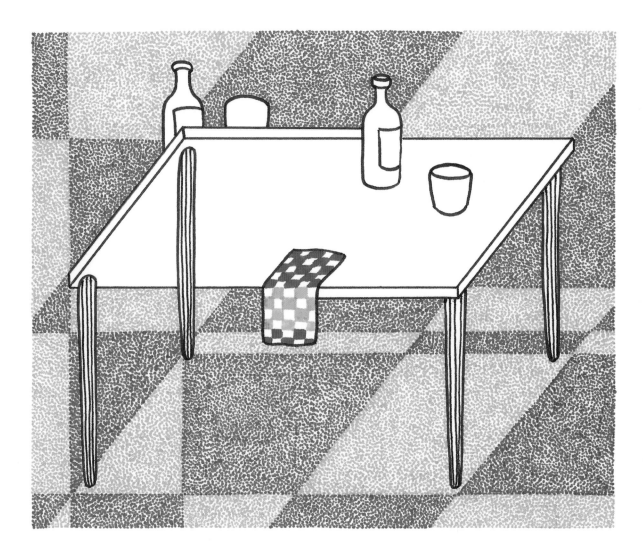

Impossible Table, 2008

Dinner would be difficult to serve on this ambiguous and impossible dinner table. Depending on how this table is viewed, it can be oriented in one of two ways: either you look down at the top surface of the table (such that the bottle and cup on the right are properly situated), or you look up at the bottom surface of the table (such that the bottle and cup on the left are properly situated).

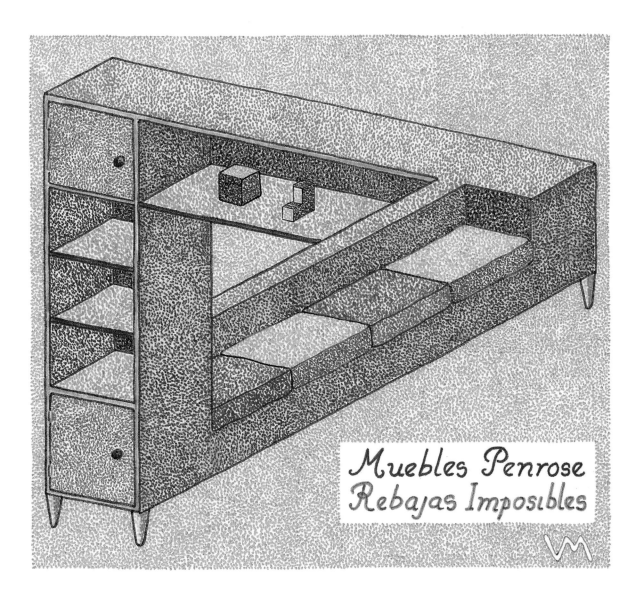

Muebles Penrose
Rebajas Imposibles

VICENTE MEAVILLA

Impossible Furniture, 2003

This unique piece of furniture is not something that you are likely to find for sale in a catalog any time in the near future. The design is based on the Penrose triangle (or impossible triangle), and features an interconnected sofa, storage unit, and shelf.

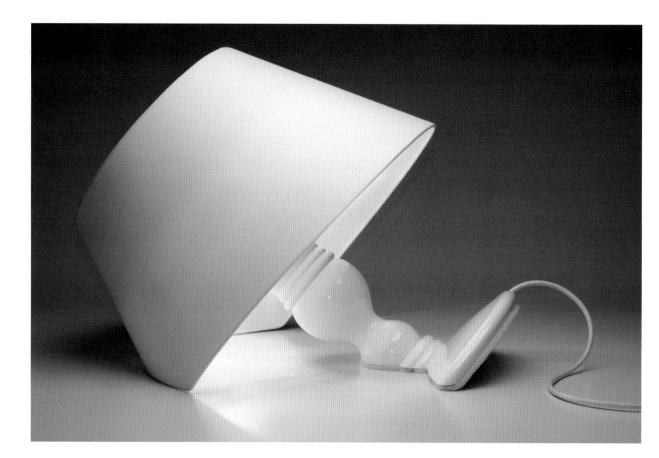

Viable London

Titanic Lamp, 2005

Viable London is a design studio recognized for its creative diversity and ingenuity. The studio designs furniture, lighting, and products, as well as conceptual installations and exhibitions, and works with international manufacturing companies and private commissions. Their distinctive Titanic Lamp design is sure to bring a "sinking feeling" to your bedroom or living room.

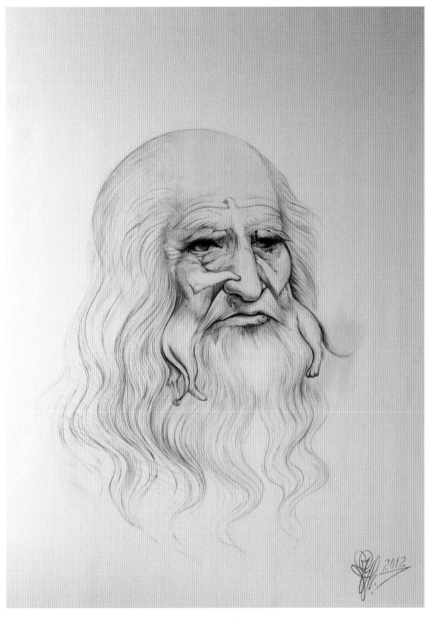

IUSTINIAN GHITA

Leonardo da Vinci, 2012

Leonardo da Vinci's "Portrait of a Man in Red Chalk" from the early 16th century is widely thought to be a self-portrait of the artist himself. The original drawing is housed in the Biblioteca Reale (Royal Library) in Turn, Italy. Due to its age and condition, the public is typically not allowed to view the original. This derivative work incorporates elements of nature, including birds, dogs, and a fish, that come together to form the man's face.

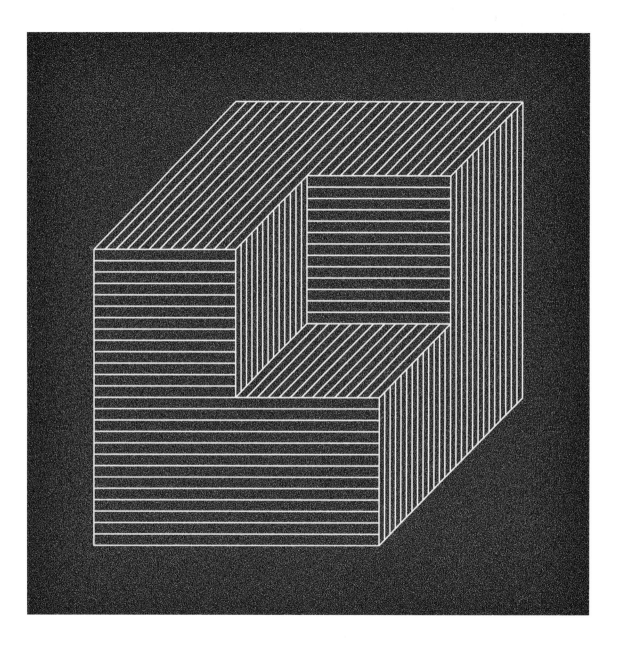

MARTIN ISAAC

Ambiguous Cube, 2009
This geometric figure has two distinct interpretations: it can be viewed as a large cube with a notch removed from one of the corners, or as a smaller cube that looks as if it were pushed into the corner of a room. You can perceive one interpretation or the other, but not both at the same time.

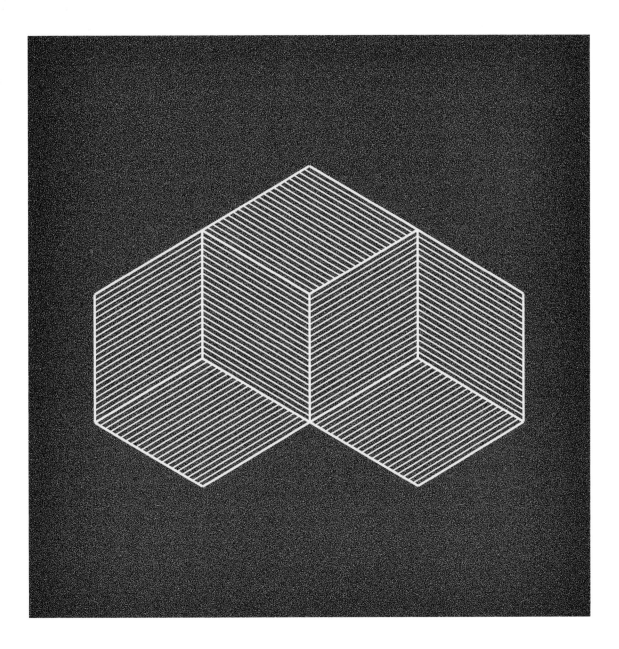

Experiment in Perception, 2009
How many cubes do you see in this figure? It is ambiguous and can be viewed as either one cube
(in the center of the figure), or two cubes (on the far left and right of the figure). Once you find
both, it is possible to flip-flop back and forth between the two interpretations.

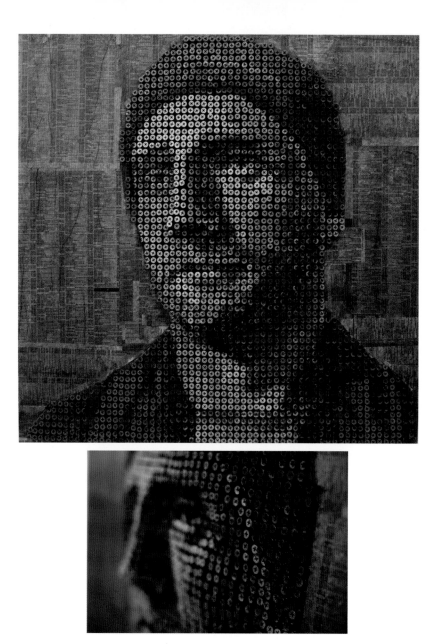

ANDREW MYERS

An Artist's Winter, 2009

Using a power drill, thousands of Phillips-head screws, oil paint, and pages from a phonebook, the artist created a portrait of himself that expressed the difficult feelings he was going through at the time. He recalls that it was a dark and cold winter outside of his studio, and it was equally dark and cold inside his soul. Myers currently resides in Laguna Beach, California, where he has lived since attending the Laguna Collage of Art + Design (formerly known as The Art Institute of Southern California).

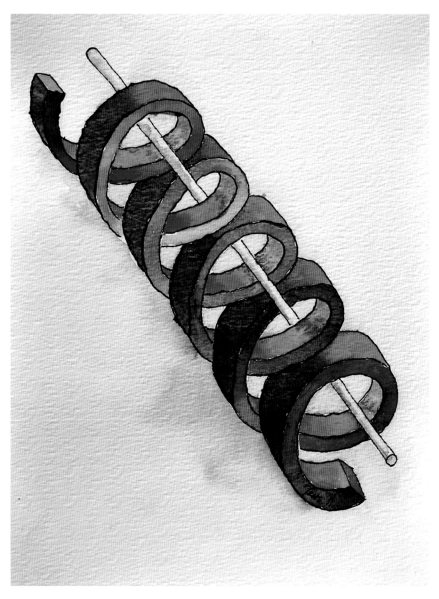

JENS MALMGREN

Impossible Spiral, 2011

Jens Malmgren was inspired to create this watercolor painting when it occurred to him that many illusionistic paintings are made from straight lines and corners. After experimenting with round lines and shapes, he eventually came up with this spiral. To enhance the impossibility of the shape, he painted a straight rod passing through the middle of it. The edge of the spiral displays the color pattern of a rainbow. While coloring the spiral, Malmgren mumbled the following mnemonic to remember the order of the colors: "Richard of York Gave Battle in Vain." The first letter of each word in this phrase corresponds with the colors red, orange, yellow, green, blue, indigo, and violet.

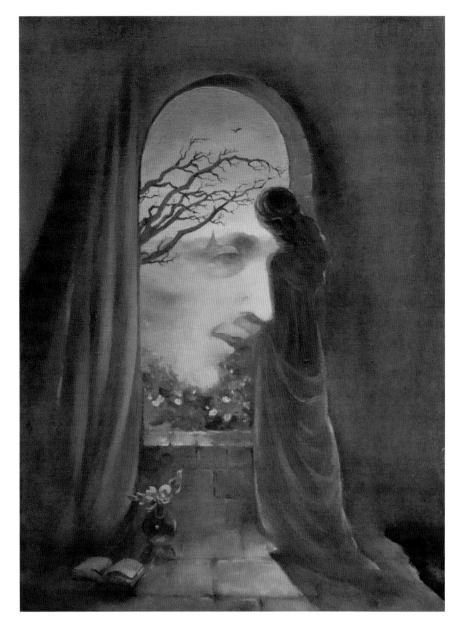

ELENA MOSKALEVA

She and He #1, 2010
This painting and the painting on the facing page are complementary illustrations created for a Russian novel written by Valentin Kuklev. The paintings tell a story about two lovers who have been separated. As she gazes out of her window and thinks about her beloved, his face appears in the landscape outside of her window. Despite the fact that he is miles away, he continues to look over and be with her.

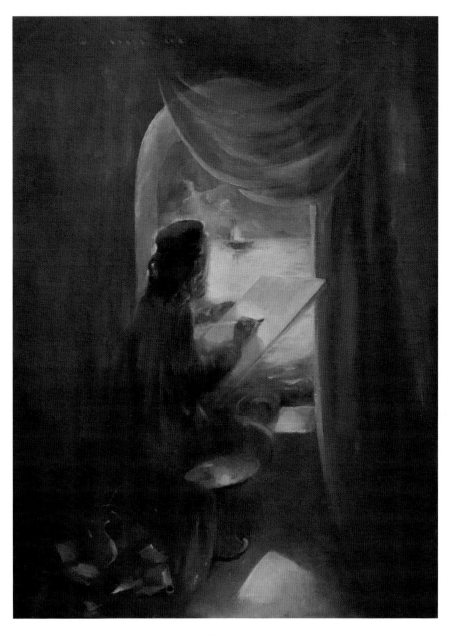

ELENA MOSKALEVA

She and He #2, 2010
At the same time, he stares out of his window and sketches a scene of a passing ship at sea on the horizon.
As he does, her face also appears in the landscape, indicating that she is watching over him as well. Moskaleva
frequently paints gentle, camouflaged landscapes resulting in a pleasant mixture of beauty and deception.

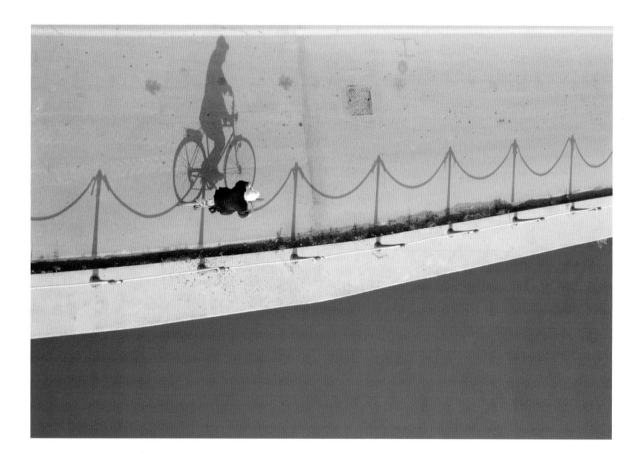

Maurizio Lattanzio

Untitled, 2011

A man is seen here riding his bicycle. At first glance, he may appear to be balancing on top of a series of sagging ropes. Upon studying this photograph in more detail, it becomes obvious that this illusion is created by the unusual vantage point that the photographer used to capture the shot. This photograph won third prize in the Carl Zeiss 2011 Photo Contest.

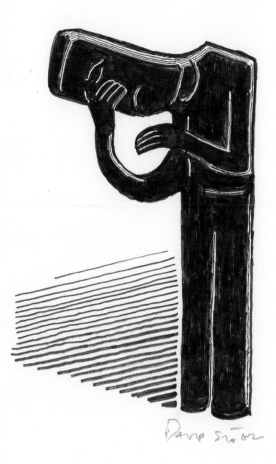

David Suter

Sad Form

This illustration, created as an op-ed illustration for an article about gun violence in a major daily newspaper, reflects the feelings of the anti-gun sector while at the same time arousing feelings from those on the other side of the debate. David Suter frequently uses this type of "double image" style in his illustrations "to point out or arouse feelings of contradiction, internal conflict or ambivalence in the minds of people as they consider issues."

FABRIZIO CORNELI

Volante II, 2006

On the wall of a loft in Brussels, Belgium, several thin, unassuming brass cutouts decorate a wall. At night, when a halogen lamp beneath is switched on (see facing page), the shadow of a man is cast onto the wall. This work measures 2 by 2 meters. Fabrizio Corneli's use of light and shadow to create functional art was inspired by anamorphic art, which has been around since the Renaissance.

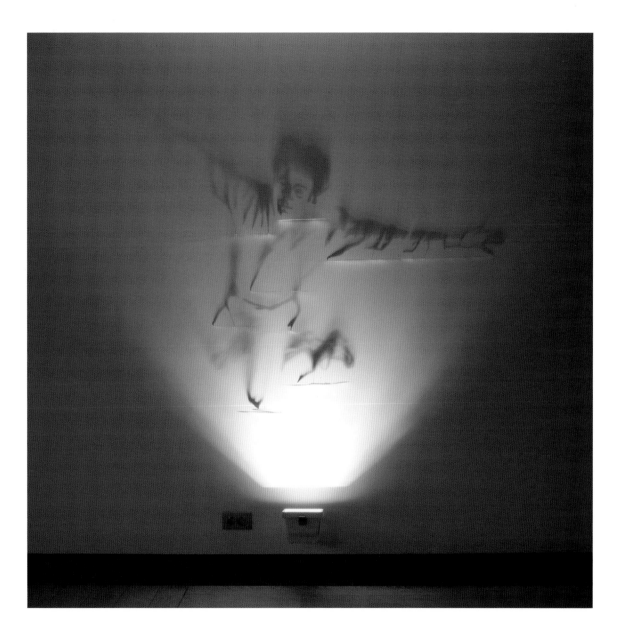

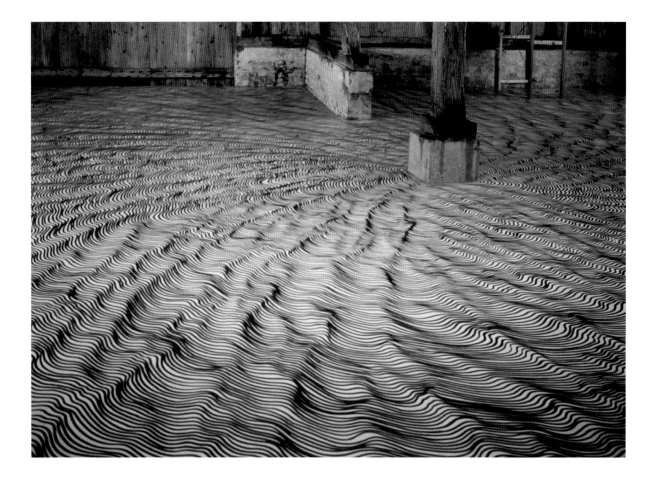

HEIKE WEBER

Stage for the Opera, 1998

Using permanent marker on polystyrene plastic, the floor of this stage for an interdisciplinary performance project was converted into a rippled and swirling surface. Heike Weber explains, "My walk-over floor and space drawings are meant to make the visitor aware of his existence, and conscious of his own person by means of how insecure he feels when walking across them."

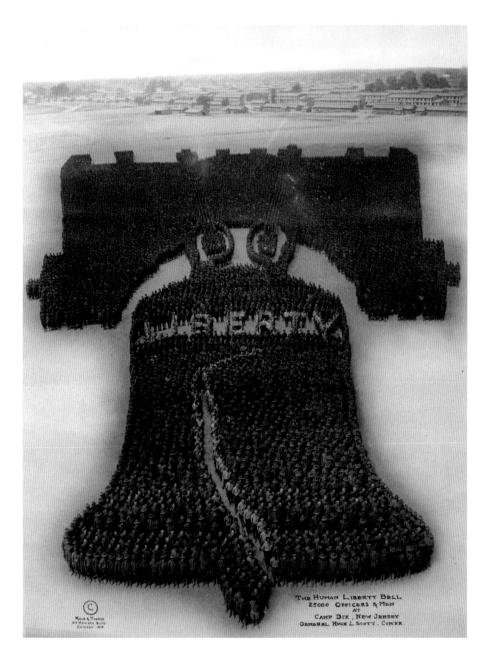

MOLE & THOMAS

The Human Liberty Bell, 1918

During the first World War, Chicago-based photographers Mole & Thomas captured a series of "living photographs" by arranging military men in ways that formed larger, identifiable, and patriotic images. This photograph features 25,000 enlisted men and officers at Camp Dix in New Jersey. When viewed from the top of a larger tower, the mass of soldiers becomes a larger image of the Liberty Bell in Philadelphia, Pennsylvania.

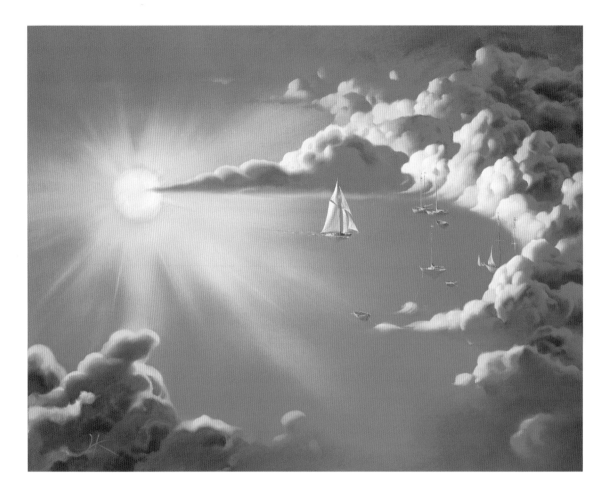

Vladimir Kush

Haven, 2001

"An artist, like a child, travels with eyes wide open," Vladimir Kush says. "He looks at the sky, as Ulysses did when thirsting for knowledge, and sees a sea and a sailboat rushing into a port where the waters are calm. Climactically surrounding all of this, like the hymn of the universe, is a brightly shining sun! This image brings to one's attention the expansiveness and eternity of the Universe."

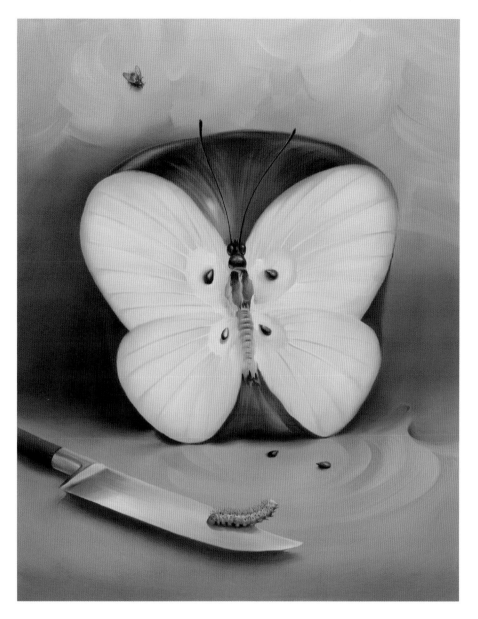

VLADIMIR KUSH

Butterfly Apple, 2001

"The ideas of an artist need time to ripen in the mysterious depths of his subconscious before appearing in a work of art, sparkling with color," says Kush. "The life cycle of the butterfly is that transformation of a vague idea into a vibrant image. The ugly caterpillar changes into a chrysalis then finally emerges as a beautiful butterfly. The chrysalis phase is hidden from man's view in this image as the artist filters out false figures and finds his way. He gains strength and then . . . take-off! He feels the tips of his fingers transform into a brush, as Salvador Dalí says, then the dormant torrents of self-expression suddenly awaken and finally break through this chrysalis-skin, filling the picture with their wings of color."

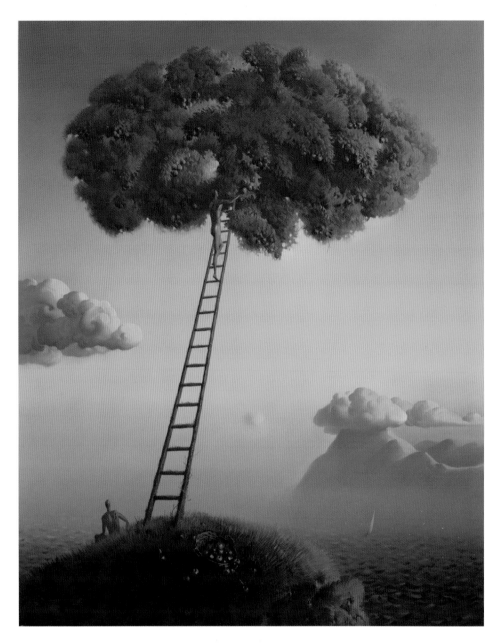

VLADIMIR KUSH

Heavenly Fruits, 2006

Kush describes his piece as follows: "Island gardens, resembling clouds, drift slowly across the golden ether over biblical hills. A ladder miraculously hovers. Migratory pickers of Eden's harvest manipulate this ladder with skill. They stride leisurely, as if walking on stilts, from one fruit-bearing crown to another, filling their baskets with celestial oranges. The weary faces of the pickers are blown by ethereal breezes and washed with clear drops of nectar."

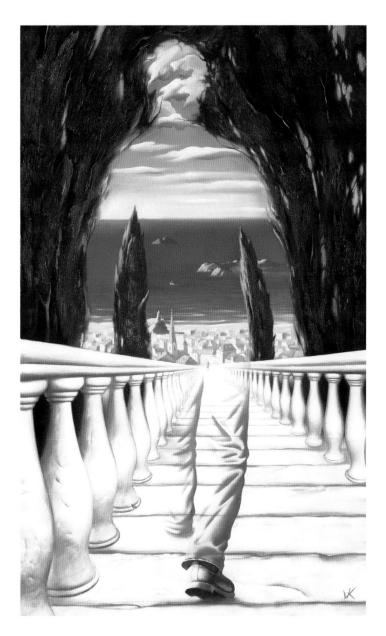

VLADIMIR KUSH

Descent to the Mediterranean, 1994

"*Mare nostrum*—Latin for 'our sea'—called ancient Romans to the Mediterranean Sea," says Kush. "And it really has become 'theirs' to the people of the North and South, West and East. Goethe, the great German poet, exclaims '*Dahin!*' (There!) in one of his poems. And having left unresolved important issues in his native Germany, he rushes south to take his famous journey to Italy. We see here, the sun-filled shadow of all travelers. These pilgrims to the Mediterranean world will descend to Italy and Greece, the Holy Land and Egypt."

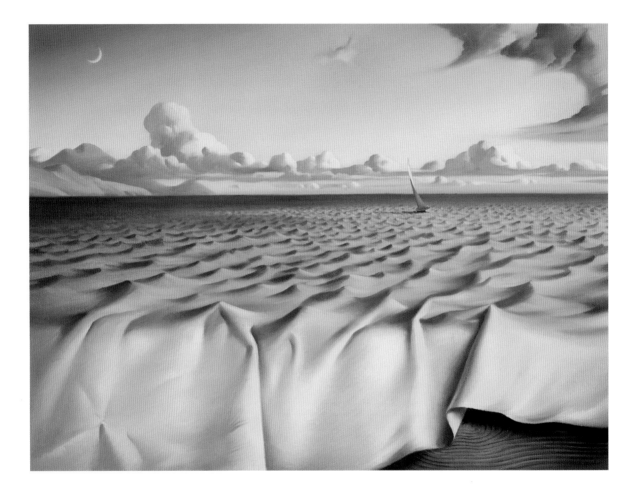

VLADIMIR KUSH

Ripples on the Ocean, 2000

"The Ocean is a symbol of infinity," says Kush in an artist statement. "In ancient Indian myths, the ocean was a never-ending entity from which originated the earth and the rest of the world, the Cosmos. Chaotic behavior is characteristic of the ocean, the motion with which everything began. In this way, the wavy ocean is our subconscious and the source of creativity. Our internal sight freely hovers over the ocean and returns to the finite by a small margin. Our perception of beauty originates from a combination of a strong harmonic start and the brute strength of chaos, the Ocean-dynamic System. The darkening blueness of the ocean approaching the horizon, a distant sailboat, and a ray slipping through the ripples on the water all intensify the picture's motive of infinity and separation from human existence."

VLADIMIR KUSH

Black Horse, 1998

"This Black Horse is an illusion," explains Kush, "yet not greater than the reflection of a horse in water. We imagine that the material being has left, but continues to exist, 'somewhere around the corner,' and his spirit has remained. In the contemporary world, virtual reality, created by electronic media, hovers in the air, influencing what is real and appearing to be more real than everyday life."

Robin Hunnam

Striped Double Cubes, 2012

Robin Hunnam studied graphic design at Ravensbourne College of Art and Design. His op art design shown here features several striped missing corner cubes. The cubes can be interpreted in multiple ways: they can resemble larger cubes with the corner nearest you missing as if it were notched out, or they can appear as smaller cubes that look as if they were placed in the corner of a room.

ROBIN HUNNAM

Double Truncated Pyramids, 2012
Hunnam previously worked as an art director at an advertising agency in London. He cites Bridget Riley, Victor Vasarely, and
M.C. Escher as artists who have influenced his style. Here, he has arranged several truncated pyramids so they appear to form a
series of strange, three-dimensional towers that bring the image to life through the depth that they create.

Robin Hunnam

Yellow and Grey Rectangular Boxes, 2012

"Great ideas are about simplicity, and about stripping away the unnecessary or the merely decorative," says Hunnam.
"Op Art is a dramatic example of the visual power of simplicity. Some of the most memorable artworks from the
movement are even devoid of color, tone, and variety of line and shape." This ambiguous striped rectangle pattern can
be interpreted in multiple ways: are the faces of the rectangles facing up and to the right, or down and to the left?

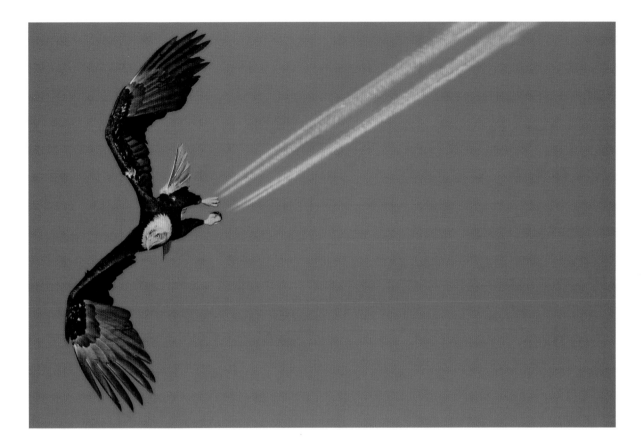

PAM MULLINS

Supersonic Eagle, 2009

"The eagle was just gliding through the sky and I was panning with my camera trying to get a good shot," recalls wildlife photographer Pam Mullins about this unintentionally deceptive photograph of a jet-powered eagle. "As I took the photo, I thought I had taken a normal picture. But when I looked back, I realized how extraordinary it looked. I thought my photo had been ruined by the jet trails! I don't know if I would have been able to take the photo if I had tried."

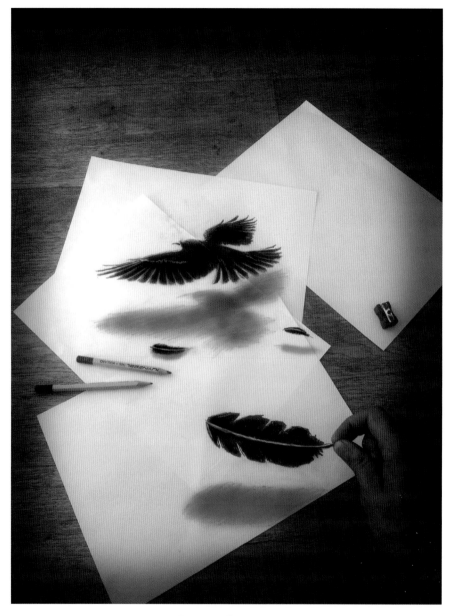

RAMON BRUIN

Feather of a Raven, 2012

Freelance artist Ramon Bruin graduated from the Airbrush Academie in Lelystad, Netherlands. While his primary focus is airbrush painting, Bruin also draws and paints with more traditional tools. The three-dimensional drawing presented here features a raven that appears to be soaring over the paper. The shadow was added to enhance the image and to give the appearance that the bird is in flight. A feather was added so that Bruin could appear to grab it, making the picture interactive and alive.

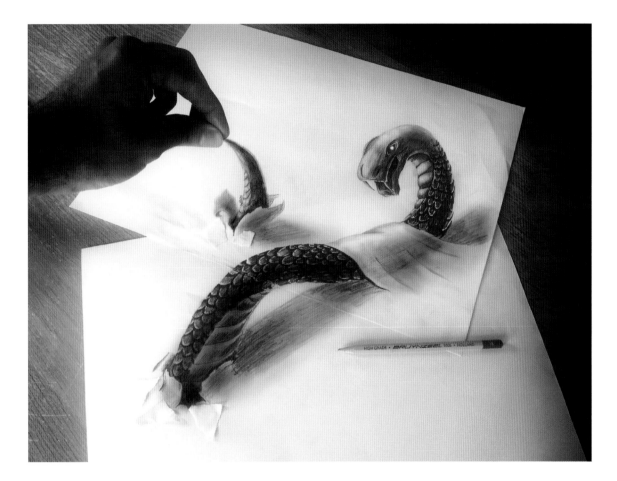

RAMON BRUIN

Snake, 2012

Bruin is always exploring new ways to create 3D artwork, and loves it when one of his drawings causes viewers to do a double take. A snake presented the opportunity for him to draw an animal that could literally jump "through" the sheets of paper while he held it by the tail. While it looks as if the snake is poised to strike his thumb and forefinger, it is doubtful that he is overly concerned.

Catherine Palmer

Tower Blocks 2, 2011

"People entering one block were surprised to find themselves in another block once they went up a few floors." Catherine Palmer based this illusion on a greyscale image, which is typically shown sideways as a series of shelving. She did not feel that the original was very convincing, so she rotated the concept into simple blocks of flats. The actual geometry behind the model is straightforward, as is the math involved in calculating the necessary amount of movement throughout the twist.

CHARLINE LANCEL

Planet Mystery, 2011

This digital op art design by Belgian artist Charline Lancel appears to be a three-dimensional sphere. Lancel creates her designs by starting with a photograph and then transforming the picture using Photoshop. "I am intrigued and fascinated by optical illusions," she says. "I particularly love spheres, which to me evoke the planets, and give me the feeling that I am connected with the cosmos."

Ghost, 2012

Focusing on the center of this array of gray circles produces a series of interesting results. Nonexistent black radial lines begin to appear, coming from the center of the image to the outer edge. Even though these lines are not part of the picture, your visual system perceives them. Some people have also reported seeing colors and peripheral rotation when staring at this figure.

RAMIRO CHAVEZ TOVAR

Rotating Drops, 2012

The outer series of blue circles appear to rotate in a clockwise direction. At the same time, the inner series of blue circles appear to rotate in a counter-clockwise direction. Through his works, Ramiro Chavez Tovar seeks to uncover how the human perceptual apparatus interacts with colors and shapes. He tries to emphasize that beyond cultural barriers, we all function equally.

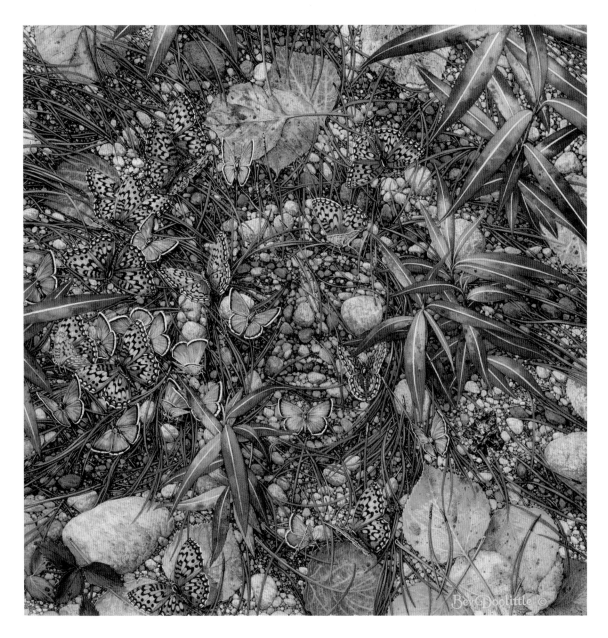

BEV DOOLITTLE

Spirit Takes Flight, 1995

"I love the wilderness, and this painting is a reflection of that love," says Bev Doolittle. "Even the most humble wilderness vista—one square foot of ground—holds immense beauty for me. It also holds the spirit of the Indian. I've used the Indian as a universal symbol of mankind living in harmony with nature. As Chief Seattle once said, 'We are part of the Earth and the Earth is part of us.' I hope this painting will help to communicate that simple, but profound, idea."

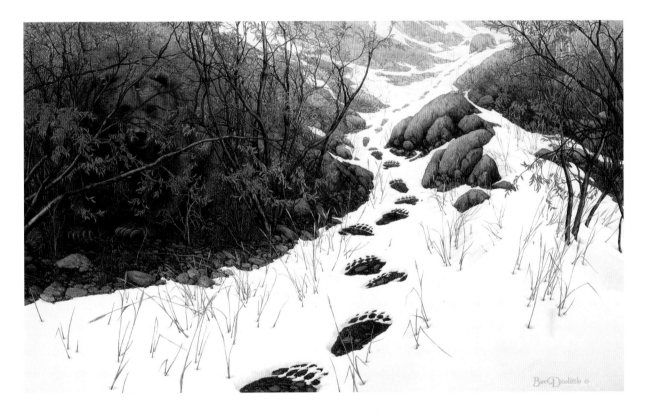

BEV DOOLITTLE

Doubled Back, 1987

In this small mountain valley, the remnant snow patches clearly show the tracks of a large grizzly bear. How long has it been since he was standing right here? Where is he now? Look closely at the tracks. The snow is crisp and clean. The edges haven't begun to melt yet. Nothing has been blown into those big muddy impressions. They are fresh. How far ahead is he? Not far, not far at all . . .

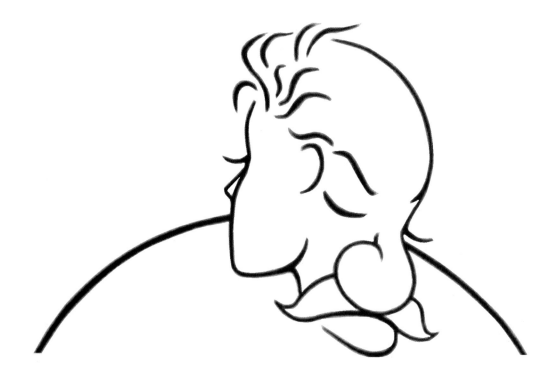

Humberto Machado

Girl and Old Man, 2007

Two interpretations exist for this ambiguous drawing: do you see a young woman looking away from you, or a bald man with a moustache and his eyes closed facing you? Can you see both figures? Influenced by W.E. Hill's famous drawing "My Wife and My Mother-In-Law," Humberto Machado was able to create this ambiguous illusion by using his mind to outline and form one character around the other.

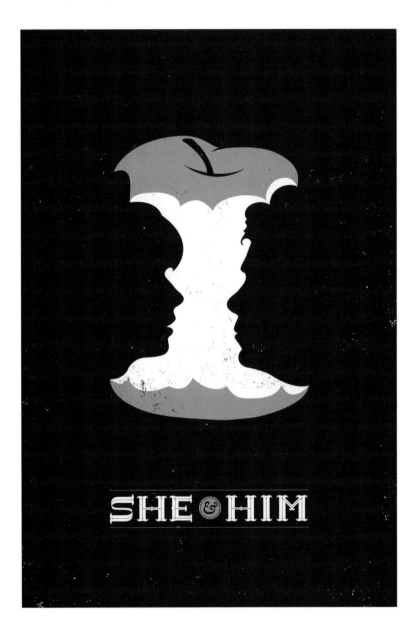

CHRIS DeLORENZO

She & Him, 2009

Originally created as a personal illustration while practicing poster design, this ambiguous image can be interpreted in two different ways: some may at first see the core of an apple, while others may notice male and female profiles facing each other. The images are reversible, but only one image can be maintained at any point in time.

Dick Termes

Eye Am a Mouth, 1972

The five sets of faces shown here interconnect, sharing elements with one another. The mouth of one face forms the eye of another, and vice versa. The mood of the faces also changes as you look from bottom to top. The lower face appears to be sad, and each face above it has a happier expression than the one below it.

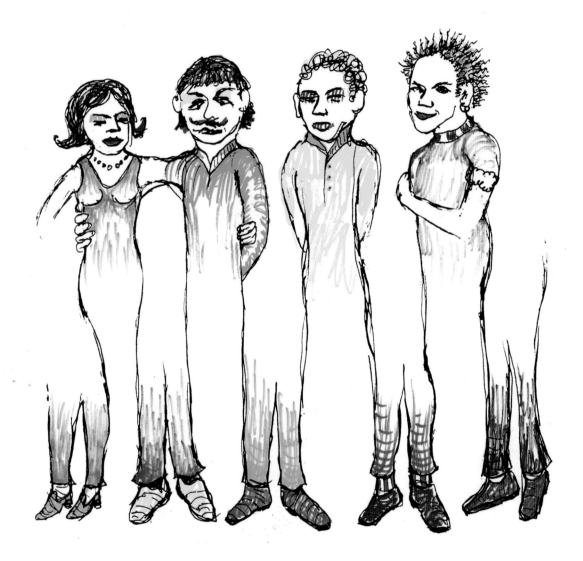

DICK TERMES

Who's Your Friend?, 2003

At first, you see four people standing. They look like they might all be friends as two of them have their arms around one another. Then, as your eyes explore the image a little further, you notice there are five sets of feet. To further complicate things, the legs on the bottom do not line up at all with the bodies at the top. The overall effect is a confusing scene that is difficult to interpret.

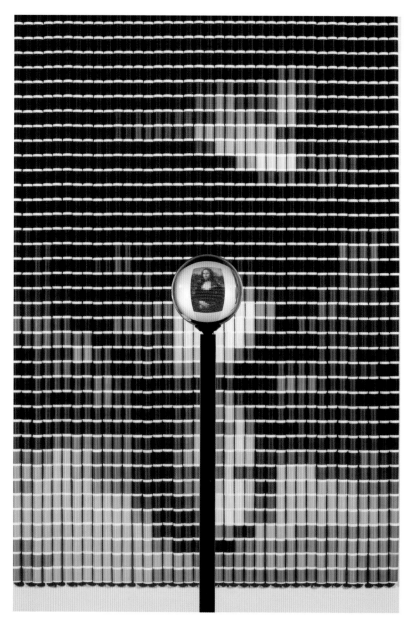

DEVORAH SPERBER

After the Mona Lisa 8, 2010
This illusion was constructed from 1,482 larger spools of thread so the image resolution is very low. Yet, when seen through a viewing sphere, the thread spools condense into a recognizable image, conveying how little information the brain needs to make sense of visual imagery it has already been exposed to. In an artist statement about this work, Devorah Sperber notes, "As a visual artist, I cannot think of a topic more stimulating and yet so basic, than the act of seeing—how the human brain makes sense of the visual world."

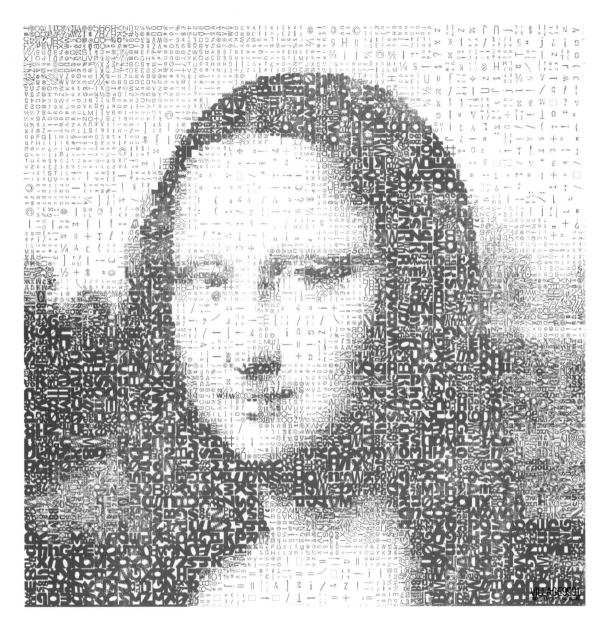

VILLAGE9991

Lisa Fontized, 2009

This handmade, text-based mosaic of Leonardo da Vinci's famous painting was created as part of a series inspired by ASCII (American Standard Code for Information Interchange) art. This art form became popular on computer bulletin board systems (a precursor to the Internet) during the late 1970s and early 1980s. The fact that most computers and printers could not display or print complex graphics led to this creative use of keyboard characters to form larger, composite imagery.

PUNYA MISHRA

Good–Evil, 2002

Two words with opposite meanings occupy the same space in this ambigram from Michigan State University Professor Punya Mishra. Regarding the creation of the design, Mishra remarked, "This is one of the few ambigrams that actually came to me 'whole'—in one flash in my mind's eye, without ever putting pencil to paper. I was driving to work after dropping my kid off at school, stopped at a traffic light, and BAM, the design just came to me. I rushed to the office, ran upstairs, pulled out my computer, and quickly created on screen what I could clearly see in my head."

PUNYA MISHRA
──────────────
Fact/Fiction, 1999
Upon first glance at this figure, do you see the word *fact* or *fiction*? Or do you see another word entirely? Oftentimes, it seems that the two are indistinguishable. Mishra asks the following about this design, "The question is . . . is that fact and fiction, or is it making a meta statement about both by actually reading faction?"

Julien Attiogbe

Melting Building, 2007

If it looks as though this building is distorted, your eyes are not deceiving you. It is meant to look this way. A *trompe l'oeil* mural has been applied to the face of this building located on Georges V Avenue in Paris, France, to create the illusion that it is melting. To create the effect, photographs of the original building were taken and then manipulated and distorted with the assistance of a computer program. These altered photographs were then printed on large canvases and applied to the building's façade.

Daniel Picon

Move 25, 2012

Daniel Picon is a French artist and author of over sixty books on subjects such as optical illusions, origami, tangrams, and more. The sphere shown here appears to be hovering above the background. This effect is achieved by the contrast between the sharply defined sphere and the blurry background.

DANIEL PICON

Birds in the Sky, 2013

Each bird is lined with black and white outlines, which leads the eye in a certain direction. If the black and white outlines were reversed on this image, the birds would appear to rotate in the opposite direction.

DANIEL PICON

Grand Z1, 2011

An iron rod with a nut screwed onto each end passes through three wood blocks. The blocks appear to be arranged horizontally, while the straight bolt cuts through each of them vertically, making the construction seem peculiar. This impossible figure was created using real pieces of wood. Cuts were made to the iron rod to make it seem to pass through each of them in an impossible way.

DANIEL PICON

3 Ladders, 2010

Three ladders lean against a white wall. The ladder on the left appears to be the smallest, while the ladder on the right appears to be the tallest. In fact, all three ladders are the same height, which can be verified by measuring each one individually. The ladders appear to be different heights due to the angle at which the photograph was taken. This type of perspective trick is frequently used in movies to make objects appear bigger or smaller than they really are.

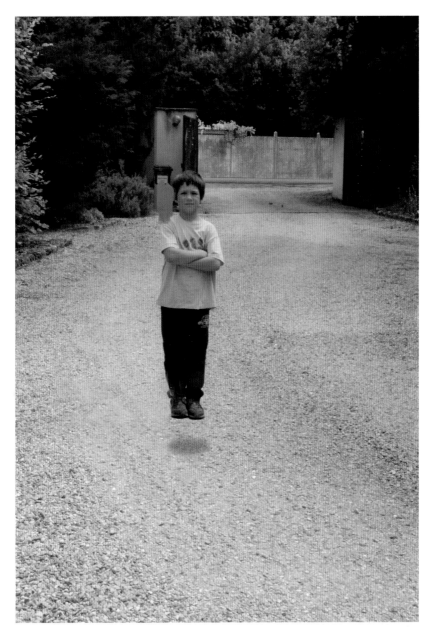

DANIEL PICON

Levitation, 2011

At first glance, the young boy standing in the middle of a driveway appears to be levitating. Is he a magician? Does he have super powers? In fact, the boy is standing firmly on the ground. Picon was able to create this deceptive photograph by carefully placing a shadow below the boy's feet. When our brain processes the scene, it assumes that the boy is casting the shadow; therefore, he must be suspended in mid-air.

Kohske Takahashi

The Blurry Heart Illusion, 2010
Two red hearts are presented on a blue background. One of the hearts is "blurry" and the other is not.
As you move your eyes back and forth between them, the blurry heart appears to wobble (as if it were
unstable), while the solid red heart does not. This illusion was presented by Kohske Takahashi, Ryosuke Niimi,
and Katsumi Watanabe from the University of Tokyo (Japan) in 2010. It was also selected as a finalist in the
2010 Best Illusion of the Year Contest hosted by the Neural Correlate Society.

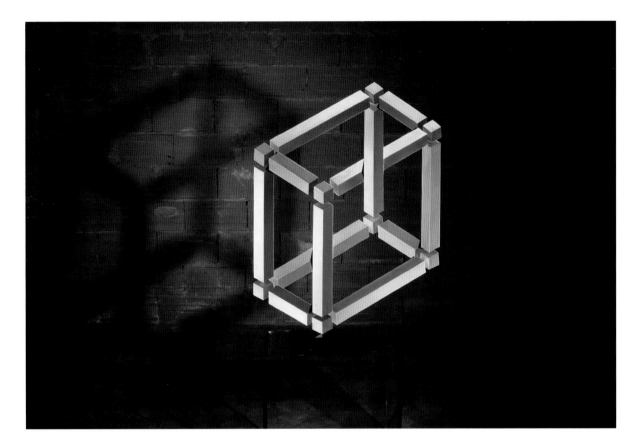

Francis Tabary

Impossible Crate, 2007

Drawing inspiration from the impossible drawings of Oscar Reutersvärd, Francis Tabary creates sculptures of objects that would have a hard time existing in our three-dimensional world. This particular example presents an impossible cube that seems to have a flaw in its construction. The vertical support board in the uppermost corner of the crate attaches to the top and bottom, yet somehow passes in front of the upper horizontal cross beam. The shadow cast by the object onto the brick wall behind it helps to give the sculpture a surreal feeling.

GUIDO DANIELE

Python, 2011

In a series called *Handimals*, Italian artist Guido Daniele uses the human hand as a canvas for creating realistic wildlife depictions. Each painting takes from two to ten hours to complete, which means the hand models lending their extremities to the project must be very patient.

GUIDO DANIELE

Elephant on White, 2007

Many of Daniele's *Handimal* creations are used for advertising and promotional campaigns. This elephant hand painting was
created specifically for a charitable campaign designed to bring awareness to conservation efforts related to the Asian elephant.

LAUREN WELLS

Stiletto, 2010

Created as part of her senior thesis at Ringling College of Art + Design in Sarasota, Florida, this illustration was intended to be part of a spread called The History of Shoes in a hypothetical fashion magazine. The concept was to design different styles of shoes made primarily with typography. "I love drawing my own typography, since I am an illustrator," says Lauren Wells, "but I wanted them to be graphic. Just clean, simple lines and shapes."

RICHARD RUSSELL

The Illusion of Sex, 2009

The two faces above are perceived to be a female and a male. Both faces, however, are the same androgynous face with a different level of contrast. This illusion demonstrates that contrast is an important cue for determining whether a face is male or female. A higher level of contrast appears to be feminine and a lower level of contrast appears to be masculine. This illusion was a finalist in the 2009 Best Illusion of the Year Contest hosted by the Neural Correlate Society.

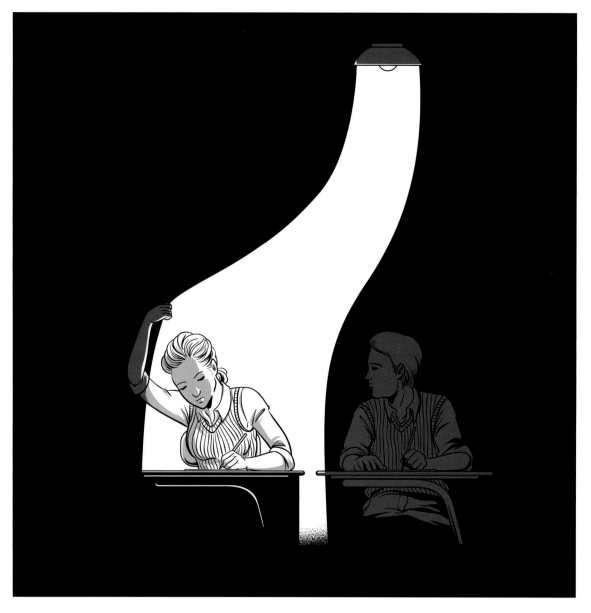

CHOW HON LAM

Light Robber, 2010

For some, a t-shirt represents an article of clothing worn as an undergarment. For others, it is a fashion statement worn as a medium of self-expression. For Malaysian t-shirt designer Chow Hon Lam (aka Flying Mouse), a tee represents a blank canvas on which a story can be told. Hon Lam's tees have proven to be tremendously popular, and have won many prestigious awards. Nearly 100,000 people have purchased t-shirts featuring one of Hon Lam's designs.

CHOW HON LAM

Milking Out, 2010

For a t-shirt designer, having Threadless (a popular t-shirt retailer) commission a design is big deal. Artists submit their designs to Threadless and the community rates the designs and provides comments over a 7-day period. Designs receiving the highest ratings become new tees sold by Threadless. Hon Lam's designs have been published by Threadless a total of 30 times—a number most graphic designers could only dream of. As a result, the Threadless community has declared that Hon Lam is a "modern legend" in the industry.

CHOW HON LAM

Shadow Crossover, 2010

"Some collaborations can be perfect, if you find the right person," Hon Lam says about this design. The two odd-looking men presented here have found that if they are careful enough, they can share the same shadow. While both might get slightly uncomfortable holding this position after a while, it would seem that the man standing on his hands has the more difficult task.

Chow Hon Lam

Shadow Worker, 2010

In 2009, Hon Lam began an ambitious project titled Flying Mouse 365 (FM365) whereby he released one t-shirt design per day for an entire year. To accomplish this goal, Hon Lam committed to the project full time by rejecting all other commissions and job offers. Thinking of an original idea and drawing it in a 24-hour period is a challenge for any talented designer. To do so every day for an entire year requires a delicate combination of creativity, skill, patience, and dedication.

Unknown

Ambiguous Horseman, 1904

Originally published in 1904, this vintage poster shows the silhouette of a man riding a horse accompanied by his dog. The image is ambiguous in that it is difficult to tell exactly which direction the man on horseback is headed. He can either be perceived as going toward or away from the baseball park where the Boston Bloomer Girls are taking on the Local Nine. The original poster was accompanied by the following caption: Is he going or coming? To the ballpark he wends his way to see the game on "bloomer day."

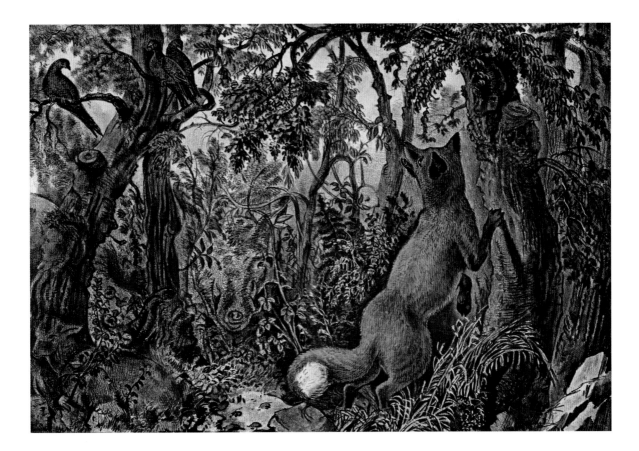

CURRIER & IVES

Puzzled Fox, 1872

Currier & Ives was an American printmaking company active during the 19th and early 20th centuries. During its time in business, it produced more than one million lithographs of more than 7,500 different images. In this popular puzzle picture published by the firm, several animals and faces can be found hidden throughout the landscape. Try to find the horse, lamb, wild boar, and the faces of men and women.

CHEMIS

Rhino Mural, 2012

This *trompe l'oeil* mural of a rhinoceros bursting through a wall was created by a graffiti writer known as Chemis. Originally from Kazakhstan, his works are known in the Czech Republic and throughout Europe. Armed with a spray can, Chemis enjoys visiting new places, experimenting with his art, making films, and working with organizations that promote human rights.

M. WHITE

White's Illusion, 1979

The gray rectangles are all of equal luminance, even though the ones between the dark stripes (on the right) appear to be darker than the ones between the white stripes (on the left). M. White described this visual phenomenon in 1979 after seeing a similar unexplained effect in an optical illusion book three years previously. Vision researchers have proposed several different explanations for this occurrence and there is currently no consensus.

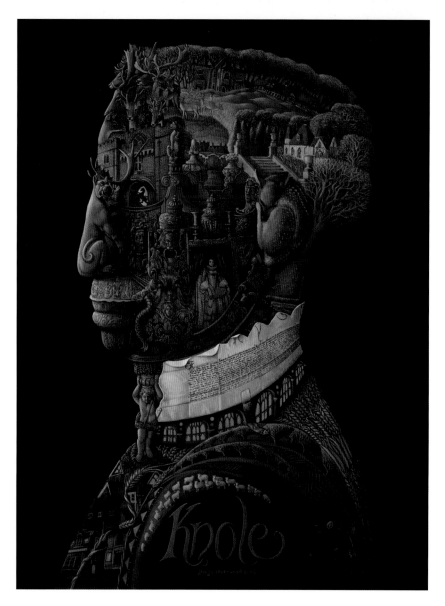

GEORGE UNDERWOOD

Knole Portrait, 2009

The artist was commissioned to create this oil painting on linen canvas by an advertising agency for a large client specializing in property management. The client desired a painting that would help explain they were experts at managing very large estates. As such, the subject chosen for this portrait was the Knole House, one of the largest houses in England located in Sevenoaks in west Kent. The artist was tasked with including as many items that represented the expansive estate as possible, which ended up including exterior features and gardens, interior objects, paintings, sculptures, furniture, and working farms and properties all within the single portrait of a man. "Not an easy task," recalls George Underwood, "but one which I relished and enjoyed doing."

Gary W. Priester

Crowded Pool, 2012

A hidden image can be revealed by staring at the pool portion of this stereogram. With your eyes about 12 to 18 inches away from the image, choose a spot in the center and stare directly at it. Continue to stare, and let your eyes relax. Try to focus your eyes as if you are trying to look through the image at something behind it. Your eyes may go slightly out of focus—this is good. After a short period of time, you may begin to see some depth. If this is the case, then you are very close. Hold your eyes on the same spot, and continue to let the hidden image move toward you. See page 223 to reveal the hidden image.

GARY W. PRIESTER

Palm Chair, 2012

This stereogram contains another three-dimensional hidden image. Gary W. Priester graduated with honors from the Art Center College of Design in Los Angeles, and spent 15 years working as a TV and print advertising director in Los Angeles and San Francisco. During the mid 1990s, Priester discovered stereograms and learned how to make them. This hobby quickly became his obsession. His stereograms have been published in numerous books, iPad apps, and magazines, and he designs custom stereograms for companies and individuals through a venture he co-founded called eyeTricks 3D Stereograms. See page 223 to reveal the hidden image.

GARY W. PRIESTER

Pyramids, 2012

Priester notes: "I prefer the challenge of designing my own hidden images and textures from scratch. It is an art form rather than a mechanical process. Creating a good stereogram involves a lot of trial and error. I never know if it is going to work, but I am always thrilled when it does. When I watch someone see a hidden 3D image for the first time, and see the sense of wonder it brings, I know the time and effort was worth it. The process is 10% art and 100% magic." See page 223 to reveal the hidden image.

PATRICK HUGHES

Picassoesque, 2013

When viewed from the front, this oil painting of a Pablo Picasso art exhibit in perspective view has the appearance of being painted on a flat canvas. Moving to the left or right (see photographs on this page and facing page) reveals that the piece is designed in a paradoxical (or reverse) perspective that Patrick Hughes calls reverspective. The work itself is actually a series of three-dimensional pyramids protruding from the frame. The portions that appear to be the farthest away when viewed from the front are physically closest to the viewer, and the portions that appear closest are farthest away. Moving from side to side while looking at one of these paintings yields another optical effect: the painting itself seems to move in a very convincing way. People continually assert that the pictures are moving even though they are the only thing in motion.

The two alternate views from extreme angles to the left and right of the painting help to demonstrate the construction of a reverspective painting. Hughes acknowledges that these types of paintings have been his most successful and they continue to intrigue him. As such, he says that he could very well concentrate on creating paradoxical perspective pictures for the rest of his days.

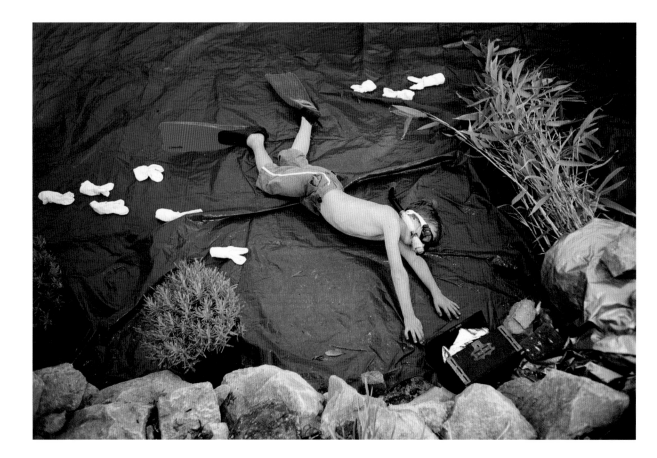

JAN VON HOLLEBEN

The Diver, 2004

This photograph is part of an ongoing series called *Dreams of Flying* inspired by classic childhood books and modern superheroes. Jan von Holleben has been producing photographs featuring children from his local neighborhood in Southwest Germany since 2002. By using carefully placed props, a ladder, and a healthy dose of imagination, he captures images that make nostalgic dreams come true.

THE KANSAS CITY PUBLIC LIBRARY

Community Bookshelf, 2004

Most parking garages in major cities provide a valuable function, but add little to the downtown landscape that they are part of. The same cannot be said for the parking garage of the Central Library in Kansas City, Missouri. By erecting 25-foot-tall book spines created from signboard Mylar around the garage, it has become a unique and striking part of the downtown landscape. This "bookshelf" features a total of twenty-two titles that were first suggested by Kansas City readers and then selected by The Kansas City Public Library Board of Trustees. Among the books featured are classics such as *Adventures of Huckleberry Finn*, *Catch-22*, *To Kill a Mockingbird*, and *The Lord of the Rings*.

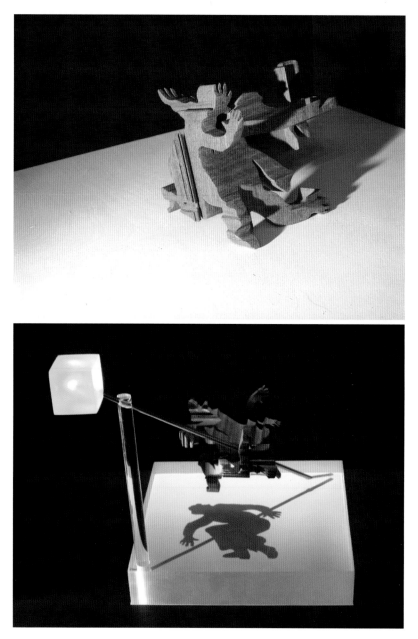

John V. Muntean

Dancers – Magic Angle Sculpture, 2012

In an artist statement, John V. Muntean writes, "Our scientific interpretation of nature often depends upon our point of view. Perspective matters." This magic-angle sculpture made from mahogany wood appears to be nothing more than an abstract carving. When lit from above and rotated at the magic angle, this carving casts three alternating shadows. With every 120 degrees of rotation, the shadows evolve into a different image of a dancer.

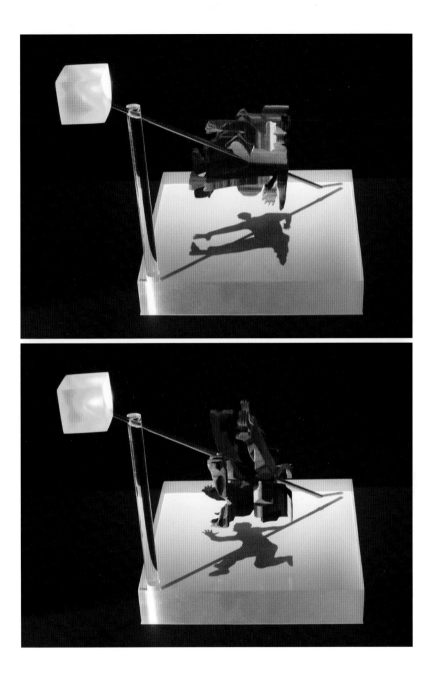

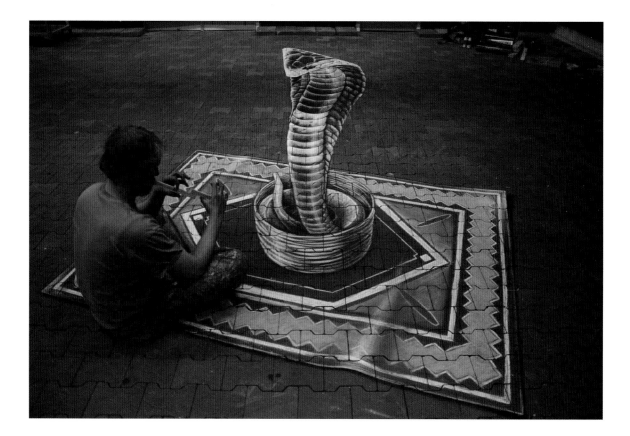

Leon Keer

3D Anamorphic Cobra, 2011

Dutch street painter Leon Keer learned to paint by designing and producing large advertising murals for multinational corporations. His knowledge of materials, acquired by painting on all types of foundations for his clients, led to an interest in experimenting with materials and techniques. This street painting of a 3D cobra rising out of a basket was created for a snake show in the Netherlands. From the angle the photograph was taken, the cobra only appears to be a few feet high. In order to make it appear to be three-dimensional, however, Keer had to paint the head of the snake very large, stretching the painting to over sixteen feet high.

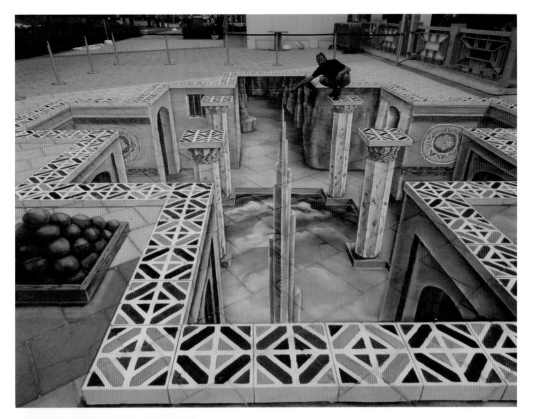

LEON KEER

3D United Arab Emirates, 2011

Street painters have to recognize and be comfortable with the fact that their paintings are not meant to be permanent pieces of art. Rain, weather, and foot traffic will eventually wear their artwork away. Keer notes, "Every street art piece is unique and belongs to the street and its residents . . . The temporary fact about this art form strengthens its existence." The work shown here was created to celebrate the 40th anniversary of the United Arab Emirates (UAE). The design, made of chalk, honors the landmarks throughout the seven emirates during their "National Day." The accompanying photograph shows the painting from the opposite angle, revealing how distorted it needs to be to appear three dimensional.

LEON KEER

Sarasota Chalk Festival, 2012

This 3D chalk painting was created for the annual Sarasota Chalk Festival in Sarasota, Florida. The painting depicts a coin-operated claw machine with a box of teddy bears and dolls waiting to be grabbed by a passerby. "The image is a metaphor for the forgotten playfulness in life," says Keer. "Never forget to explore your creativity by keeping your inner child close."

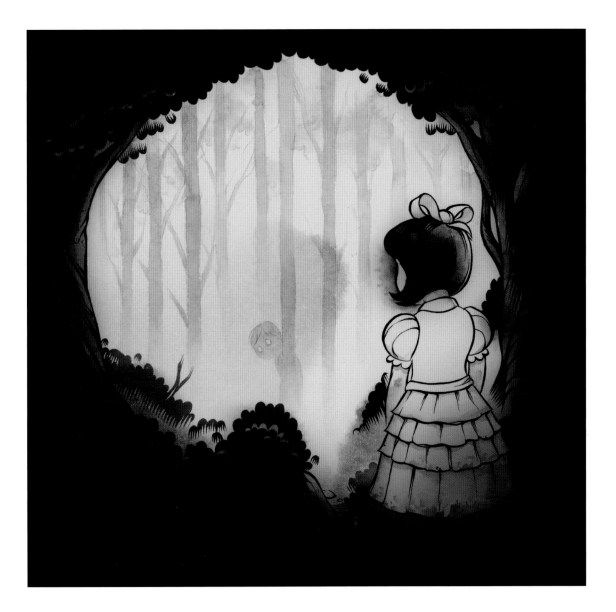

Karl Kwasny

The Forest, 2011

"Deep in the forest, where heavy feet sink, you mightn't be quite as alone as you think." Illustrator Karl Kwasny (aka Monaux) penned the previous line to accompany this design. While it initially looks like an innocent drawing of a young girl peering into the woods, a hidden image reveals a much darker double meaning. This illustration was commissioned by the online t-shirt community, Threadless.

JANE PERKINS

Sunflowers, 2011

In an ongoing body of work called Plastic Classics, Jane Perkins gives a contemporary twist to the paintings of the Old Masters. She uses anything that's the right size, shape or color including toys, shells, buttons, beads, jewelry, curtain hooks, springs, etc. No color is added; everything is used exactly "as found." The work can be viewed in two ways: from a distance to make sense of the whole image, or close up to identify the specific materials used. The three-dimensional nature of Vincent van Gogh's thickly applied paint, which he squirted straight from the tube, lends itself perfectly to re-interpretation using found materials.

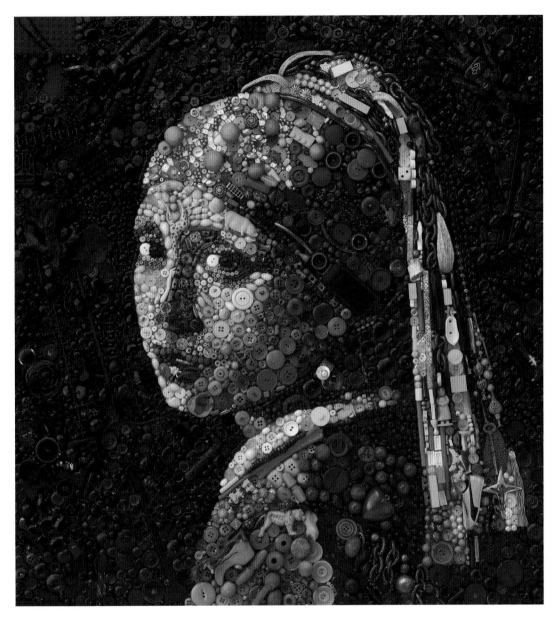

JANE PERKINS

Girl with a Pearl Earring, 2011

The re-interpretation of work by previous artists is not a new phenomenon. Centuries ago, artists learned their craft by re-working paintings by their more famous predecessors. Tracy Chevalier, the author of the bestselling novel *Girl with a Pearl Earring*, had the following to say regarding this derivative work: "What a gorgeous re-interpretation of the painting! I often see people's reproductions of Vermeer's Girl, and few 'get' it. Jane Perkins has taken the portrait a step beyond and made it her own—a textured image that I bet would have made Vermeer smile."

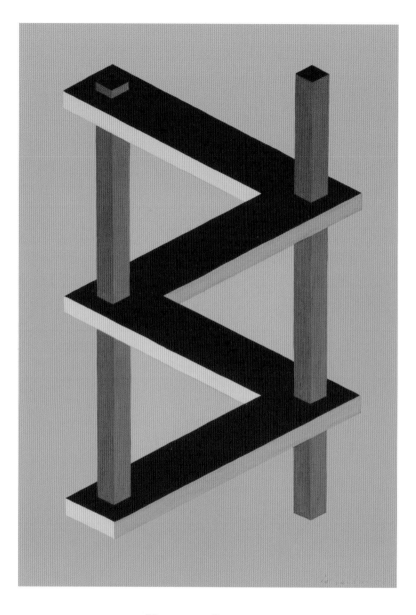

Hermann Paulsen

Düsseldorf Triangles

German artist and teacher Hermann Paulsen had a special interest in the development of impossible figures. In this painting, two vertical posts pass through multiple points of the horizontal zigzag figure in a manner that would not be physically possible. In doing so, three impossible triangles are formed.

Hermann Paulsen

High-Energy Ball on a Red Background

In 2013, the Phänomenta Science Center in Flensburg, Germany, hosted a Hermann Paulsen retrospective exhibit featuring his impossible figures. The "Impossible Possible" exhibit was designed by art students at the University of Flensburg working in conjunction with Phänomenta personnel. The flat geometric pattern presented here has the appearance of being spherical. As such, Paulsen referred to this three-dimensional figure as a "high-energy ball."

Hermann Paulsen

Untitled

Two blue and three yellow impossible triangles are connected in an overlapping and
interlocking pattern. Further, the largest triangle wraps around a figure shaped like a partial
cube. The result is a tangled knot that can only exist on paper or the imagination.

Hermann Paulsen

Untitled

The red and yellow figure in this painting initially appears as a cube. Further inspection reveals that the figure is not cubical at all. Rather, the outer edge is a hexagon formed from six impossible triangles. The blue figure twists and bends around each of the triangle sides, further rendering this figure impossible.

JOHN LANGDON

Excellence, 2008

John Langdon loves working with words. He is a logo designer, typography specialist, and Professor of Typography at Drexel University in Philadelphia, PA. Along with Scott Kim, he is one of the originators and pioneers of the art of ambigrams. Langdon created this design that can be rotated 180 degrees and remain the same word on a commission from The Guthrie Center in Houston, Texas, to help promote the school.

IS A SCIENCE DEFINED AS THE PURSUIT STUDY&LOVE OF WISDOM.

MAY ALLOW OR REQUIRE LOOKING AT IDEAS FROM BOTH SIDES.

JOHN LANGDON

Philosophy, 1985

"This ambigram is particularly meaningful to me," Langdon says. "My ambigrams came about in the first place as an expression of my personal philosophy that was built around the yin/yang symbol. I always like to have the two blocks of text accompanying this ambigram, as they very concisely capture my feelings about all my work."

JOHN LANGDON

Logos, 2006

This design was commissioned by an individual for use as a tattoo. Perhaps surprisingly, this ambigram does not refer to more than one logo. Instead, the word refers to the Greek word logos, which he describes as "the underlying order of reality, of which ordinary people are only unconsciously aware. It is the 'way things are,' the totality of the 'laws of nature.'"

JOHN LANGDON

Reality, 2004

Langdon designed this rotational ambigram for the second edition of his book *Wordplay*. "Inasmuch as a great deal of philosophy is an inquiry into to the nature of reality, I have given a great deal of thought as to how one's own 'reality' relates to a greater—perhaps 'objective'—reality. I had come up with a diagram that addresses that relationship, and wanted to include "Reality" as a topic in Wordplay, so an ambigram was called for. It's particularly gratifying when one of my 'important' concepts can be represented by an aesthetically pleasing ambigram."

John Langdon

Transparent, 2004

Langdon is always pleased when he can create a tangible work that simultaneously captures both the verbal and visual/ambigrammatic characteristics of a word. Here, a mirror-image ambigram featuring the word "transparent" has been etched onto a piece of glass. This word reads exactly the same when viewed from the other side of the glass.

Department of English & Philosophy College of Arts & Sciences

JOHN LANGDON

Philosophy/English, 2007

"This illusion was a particularly difficult challenge," said Langdon. "My attempts to create more 'conventional' (rotational, mirror-image, etc.) ambigrams for these two words were unsuccessful. But my personal investments in both philosophy and language seem to inspire me to some of my best work. This 'perception shift' ambigram was very difficult to develop, but my stubborn persistence finally paid off. The two words 'philosophy' and 'English' can be difficult to discern, but with a little patience and a voluntary perception shift, finding them is particularly satisfying."

RICHARD WHEELER

Escherlators, 2012

This photo manipulation was created as homage to the late Dutch artist M.C. Escher. It depicts what his famous 1953 *Relativity* lithograph might have looked like had Escher lived in the 21st century. Both works feature a series of impossible stairways that defy gravity as they head in multiple directions within the same three-dimensional space.

Nicholas Wade

Chrys, 1980

The portrait of a woman hides among this series of white circles. Can you find it? If you are having trouble seeing it, you may want to stand farther away from the page and/or squint your eyes. The curved lines were drawn by hand and then photographed using high contrast film. The face was photographed, reduced to high contrast, and then combined photographically with the graphic. In a recent paper titled "Hidden images," Professor Nicholas Wade states, "It is relatively easy to hide pictorial images, but this is of little value if they remain hidden. The skill is in revealing previously concealed images."

Apunte, 2005

Augusto Zanela's anamorphic installation presented here (and on the facing page) was created for the Museum of Modern Art in Buenos Aires, Argentina. Using a projector, screen, paint, and adhesive vinyl, he has transformed a simple hallway into a work of art. When viewed from a fixed location, it appears that three concentric circles are present. Moving to any other viewing angle reveals exactly how this illusion was constructed. Zanela holds a degree in Architecture and Urbanism from the University of Buenos Aires.

ISTVÁN OROSZ

Pergola, 1993

"There are things I can imagine and I can draw," says István Orosz. "There are things I can imagine but I cannot draw. But, could I draw something that I cannot imagine? That interests me greatly." Something about the construction of this pergola from the imagination of Orosz is peculiar. The support beams look as if they would have no trouble holding up the roof, but would they?

ISTVÁN OROSZ

Ship of Fools IL, 2005

This illustration was created as part of a series of similar images for a Hungarian/German edition of Sebastian Brant's 15th-century satirical book, *The Ship of Fools*. It depicts a busy castle scene with many different people engaged in their daily activities. The scene also has an alternate darker interpretation, as the castle itself resembles a human skull. The illusion is more prominent when viewed from a distance.

ISTVÁN OROSZ

Lamarck, 2002

A collection of miscellaneous objects on a set of shelves transforms into a portrait of French biologist Jean-Baptiste Lamarck. Quite fittingly, the objects that define his likeness are all related to nature. A caged bird and drawings of a rhinoceros and a bird on a tree come together to form the outline of his head and face. An octopus and insect double as his eyes, while a fish forms his mouth.

ISTVÁN OROSZ

Window with Ivy, 1993

On the side of an ivy-covered building lies a paradoxical window open to let in fresh air. The top half of the window appears to be opened outward and facing to the right. The bottom half shows a window that is opened inward and facing to the left. Each half looks completely normal, but when viewed together, they reveal the impossible nature of the architecture.

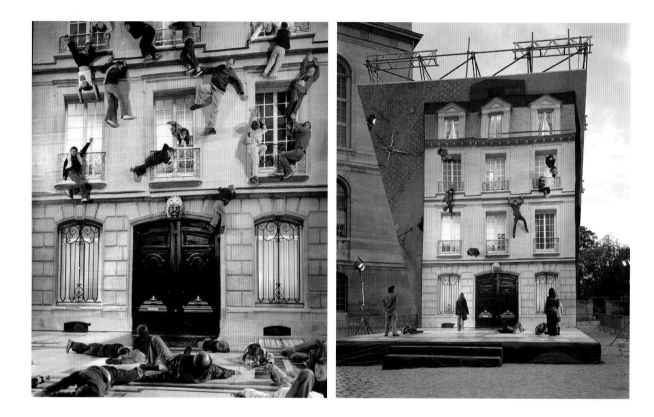

LEANDRO ERLICH

Bâtiment, Nuit Blanche, Paris, 2004

"It is a mirage, a reflection in the mirror," said Leandro Erlich about this installation in a 2008 interview with
ArtNexus. "There is no mysterious technique beyond the grasp of the viewer, who after a while discovers that
the people who seem to be climbing up the walls are grounded on the floor, on a model of a building's façade.
Reflected on a mirror, they seem to be in a vertical position and not horizontal, as they truly are."

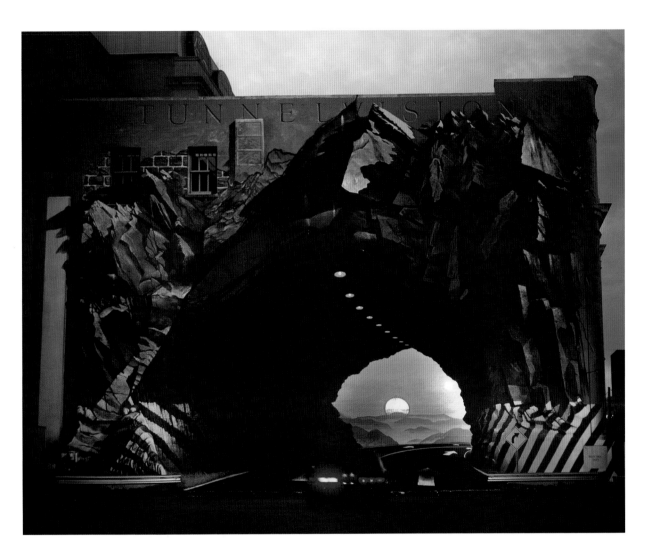

Blue Sky

Tunnelvision, 1975

Measuring a stunning 50 by 75 feet, this *trompe l'oeil* mural resides on the stucco wall of a bank in Columbia, South Carolina. Even drivers paying full attention to the road in front of them are fooled when they first encounter this rock tunnel with the orange sunset in the distance. The idea for this deceptive masterpiece came to the artist in a dream. He woke up one morning and sketched it out after previously studying the wall. Not surprisingly, the mural took an entire year to complete.

EPILOGUE

FROM DECEPTION TO ART—ADDING MEANING TO OPTICAL ILLUSIONS

Optical illusions deceive our senses. A line that appears curved is actually straight; a shape that appears convex is actually concave; a painting of a landscape actually contains a hidden face. Now, normally we don't like being deceived. To be fooled is to be hoodwinked, bamboozled, taken in. So why do we enjoy being deceived by optical illusions?

Teller—the mute half of the magic act Penn & Teller—explains: "The most important decision you make in your life, at any given moment, is deciding what is really going on. If you make a mistake about that in real life, like not believing that a truck is coming at you, it can be fatal. Magic is a playground for playing with that most important decision in a situation where it doesn't matter." Thus, magic tricks, like optical illusions, command our attention because they deal with something vitally important to all of us— our perception of reality.

But mere tricks get old fast. Just as a master magician uses the mechanics of magic to stage memorable dramas, so the artists in this book use the mechanics of illusion to create meaningful images. The range of work is vast—we have painting and illustration next to sculpture and photography, fine art next to scientific studies, whimsical jokes next to passionate political statements. Here are some of the many ways the artists in this book have transformed deception into art.

THE SCIENTISTS

Sometimes, the presentation of an illusion in its most basic form has an austere beauty of its own.

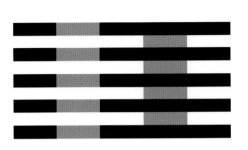

M. White's *White's Illusion* is both a striking abstract composition that invites repeat viewing, and an iconic presentation of a mysteriously powerful illusion.

Psychologist Roger Shepard is also an artist, so he added just enough visual cues to his *Turning the Tables* illusion to make us see the quadrilaterals as tabletops.

THE FORMALISTS

Some artists explore illusions in their purest geometric form.

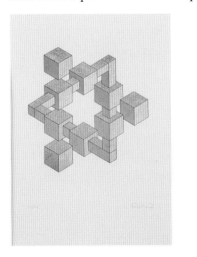

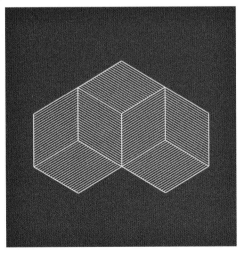

Impossible object pioneer Oscar Reutersavärd drew thousands of permutations on one basic illusion. Although the forms are abstract, the spirit is unmistakably playful.

Artist Martin Isaac's *Experiment in Perception* uses spare forms and austere colors to create an intensely quiet meditation on the spatial ambiguity of isometric cubes.

THE INTERPRETERS

Other artists embellish classic illusions by showing them in fresh contexts. There are no deep messages here, just delightful creativity—like hearing a new arrangement of an old tune.

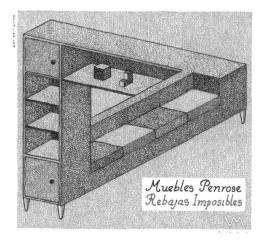

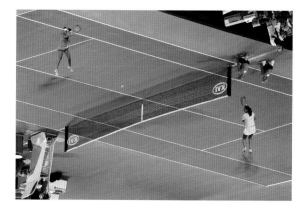

Vicente Meavilla's *Impossible Furniture* translates Reutersvärd's impossibly twisted triangle into a charmingly mundane form.

Michael Kai presents the concave/convex illusion from Martin Isaac's *Experiment in Perception* in a startling photographic context in *This Side Up – Tennis*.

THE SCULPTORS

Familiar illusions can take on new life when given 3-dimensional treatment. In both of these illusions, sculptural reality adds a new dimension of meaning.

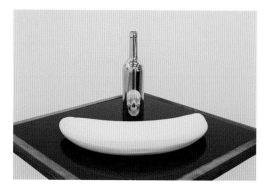

In traditional anamorphic paintings, the reflective cylinder is merely the viewing mechanism, and the source image is flat. In James Hopkins' *Ghost*, a reflective bottle becomes part of a sculptural composition. A poisoned drink, perhaps?

Bela Borsodi's *VLP* would be unremarkable if it were a flat painting or photographic collage. But as a single unretouched photograph of real objects, it engages us in a game of "how did he do that?"

THE ENTERTAINERS

Throughout history, illusions have been used to amuse and entertain.

Long before the Internet, lithographs such as *Puzzled Fox* by Currier & Ives were popular amusements. The game is to find animals and human faces hidden in the scene.

Nowadays, amusing illusions such as Chow Hon Lam's *Milking Out*, which was created for a t-shirt design, prove similarly popular.

HUMOR AND FANTASY

Impossible images invite us into a world of fantasy and play. These illusions do not fool us for more than a moment, but we willingly suspend our disbelief to enjoy the fantasy.

Titanic Lamp by Viable London invites us to believe that the table is a pool of liquid.

Melting Building by Julien Attiogbe disrupts the straight lines of the urban landscape.

DO IT YOURSELF

Illusions constructed out of familiar materials invite us to participate and try it for ourselves.

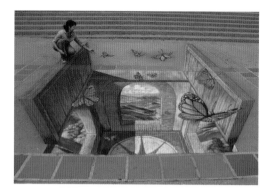

Tracy Lee Stum's chalk drawing *Butterflies over San Luis* transforms a familiar space into something magical. Viewers become participants by walking around it and photographing it.

The Diver by Jan von Holleben uses a simple trick of camera angle to invite us into the imagination of child. What sideways scene would you photograph?

THE QUESTIONERS

These artists question the nature of reality by making us choose between two different images.

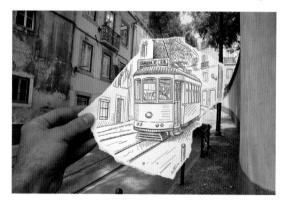

Ben Heine's *Pencil vs. Camera – 4* asks us to consider the relationship between a drawing and a photograph. Both represent reality, but which one is the truth?

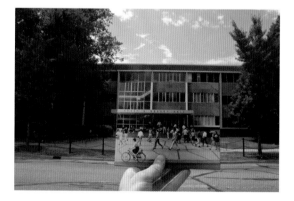

Michael Samsky's *MSU Then and Now* uses a similar device to very different effect. Instead of questioning the reality of the image, we think about memory—the collision of past and present.

THE ILLUSTRATORS

These illustrations use ambiguous images to show multiple aspects of a single situation. Although these images do stand on their own as interesting compositions, they were originally created to illustrate specific stories.

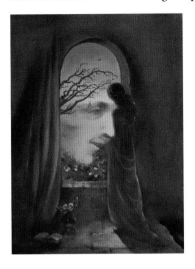

Elena Moskaleva's *She and He #1* concisely expresses the relationship between the present woman and her distant lover.

David Suter's *Sad Form* was created to illustrate a newspaper opinion piece about gun violence. Not only did the artist fuse human and gun forms, he also creates ambiguity as to whether the image is pro- or anti-gun control—perfect for illustrating a controversial issue.

THE DISCOVERERS

These two unretouched photographs record remarkable visual discoveries.

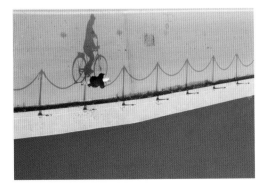

This untitled photograph by Maurizio Lattanzio poses a question: how does the bicycle balance on the chain? As we answer the question, we discover a different way of viewing the scene.

Mother Nature in Tears by Michael S. Nolan records an extraordinary coincidence: an actual unretouched scene creates an unmistakable and powerful visual metaphor.

THE DREAMERS

These artists paint surreal images that blur the edges of reality, creating impossible scenes that invite us to dream.

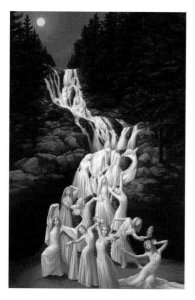

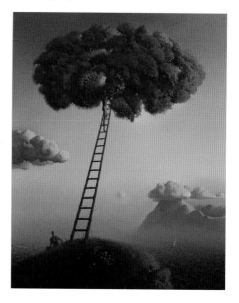

Rob Gonsalves describes his work as "Magic Realism," a term from literature in which an otherwise realistic narrative incorporates magical elements. Above, *Water Dancers.*

The impossibility of the scene lifts the painting from the mundane to the mystical. Above, *Heavenly Fruits* by Vladimir Kush.

THE PHOTOGRAPHERS

Photography adds a new dimension to magical realism because we expect photographs to document reality.

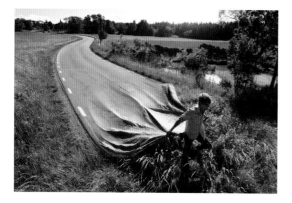

In Erik Johansson's *Go Your Own Road,* two materials blend in an impossible way.

In *Piano Peace,* Thomas Barbèy blends several photographs to create a striking visual pun.

THE ARTISTS

These artists use illusion as a means to express deep feelings, not as an end in itself.

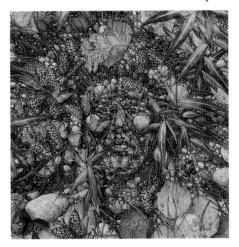

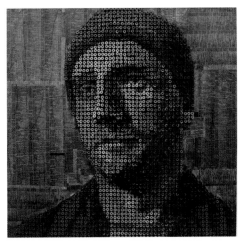

In Bev Doolittle's *Spirit Takes Flight*, as in all of her work, hidden images show us the spirit that animates the natural world.

There is illusion here: our perception alternates between seeing the screws and seeing the face. But what most strikes us is the materials: the cold metal screws and gray newspapers create a bleak feeling. Above: Andrew Myers' *An Artist's Winter*.

THE VOICES

Finally, these artists use the shock of illusion to open up conversations.

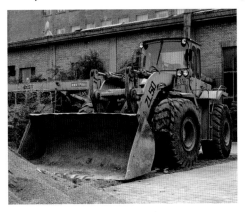

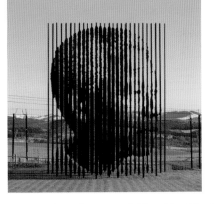

By camouflaging his presence, the artist asks us to consider what we are becoming. The power of the image comes from its implicit promise: the artist endured hours of immobility to make this image—a radical choice in the age of digital retouching. Above: Liu Bolin's *Hiding in the City No 71 – Bulldozer*

In this sculptural portrait of Nelson Mandela, the artist uses a perspective illusion to create a powerful and memorable symbol of unity. Above: Marco Cianfanelli's *Release*

—**Scott Kim**
Puzzle Designer, Artist, and Author

IMAGE CREDITS

GARY W. PRIESTER REVEALS FROM PAGES 179-181

For Gianni A. Sarcone's *Hidden Giraffe* on page 82, try looking at the neck of the giraffe in the foreground.

For *The Miller* on page 88, rotate the puzzle counter-clockwise by 90 degrees. The face of the miller can be found on the body of the horse.

For *H.M.S. Pinafore* on page 89, rotate the puzzle 180 degrees. When this scene is viewed upside down, the ship becomes the head of the captain.

ACKNOWLEDGMENTS

I owe a debt of gratitude to every artist appearing in this book. Without them, this project would not have been possible. I would like to extend special thanks to the following individuals for their assistance, contributions, guidance, inspiration, support, and encouragement:

Terry Stickels, www.terrystickels.com

Scott Kim, www.scottkim.com

John Langdon, www.johnlangdon.net

Gene Levine, www.colorstereo.com

Nikita Prokhorov, www.nikitaprokhorov.com

Anatoly Kalinin

Ellen Doepke from Michigan State University

Gianni A. Sarcone and Marie-Jo Waeber from Archimedes Lab, www.archimedes-lab.org

Sorche Elizabeth Fairbank from Fairbank Literary Representation, www.fairbankliterary.com

Klim Altman and Elizabeth Teberio from Visions Fine Art, www.visionsfineart.com

Boots Harris and Kerilynn Vigneau from Huckleberry Fine Art, www.huckleberryfineart.com

Wendy Wentworth from The Greenwich Workshop, Inc., www.greenwichworkshop.com

Polina Hryn from Kush Fine Art, www.vladimirkush.com

Steve Christian from Kapan Lagi, www.kapanlagi.com

Achim Englert from Phänomenta Science Center, www.phaenomenta.com

Vlad Alexeev from Impossible World, www.im-possible.info

INDEX